50 GEM

Cornwall

JOHN HUSBAND

AMBERLEY

First published 2019

Amberley Publishing
The Hill, Stroud
Gloucestershire, GL5 4EP

www.amberley-books.com

British Library Cataloguing in Publication Data.
A catalogue record for this book is available from the British Library.

ISBN 978 1 4456 8911 1 (paperback)
ISBN 978 1 4456 8912 8 (ebook)

Typesetting by Aura Technology and Software Services, India.

Printed in Great Britain.

Contents

Introduction

Cornwall is a popular holiday destination best known for dramatic coastal scenery and wonderful beaches. It is hardly an exaggeration to say that the Cornish landscape is the star of the BBC's latest dramatisation of Winston Graham's *Poldark* novels. It is no surprise that Cornwall boasts twelve ANOBs (Areas of Outstanding Natural Beauty). In this guide I would like to take the reader on a tour of the places that are a little off the track so well beaten by tourists. We will bypass the Eden Project, National Trust Gardens and honeypot fishing villages, which are well signposted and you can easily find them for yourself. Instead we will head for the locations where Cornwall's true character can still be found, but from where the brown tourist signs are often absent. The coast still features heavily, of course; how could it not with a coastline that is 296 miles long? The coast path takes us to dramatic cliffs, which are ablaze with colour in spring, and smaller coves and harbours where sustainable fishing still goes on much as it did in the past, but on a smaller scale and with more modern equipment. There are also surprises: who would think that a sandy beach in west Cornwall was the focal point of a global communications network?

Cornwall's heritage can also be found in the many prehistoric sites that dot the landscape of the inland moors, surrounded by the remains of ancient volcanoes that form the tors and crags of Bodmin Moor and West Penwith. Just have a look at the Ordnance Survey Explorer maps of these moors, a great activity for a wet winter's day. It is thought that Bronze Age cairns like those found on the summit of Cornwall's highest peak, Brown Willy, may be the derivation of the name Kernow, from the Cornish 'karnow' or 'rock piles'. More recent remains are found here too, the romantic outlines of ruined engine houses left behind after the mining boom of the eighteenth and nineteenth centuries, which now form part of the Cornwall and West Devon Mining Landscape World Heritage Site. While the Cornish language is no longer used in everyday life, there are bilingual street signs and a renewed interest in it academically, especially among those who regard Kernow as having a separate national identity to the rest of England. Hence St Ives is also known as Porthia, and Falmouth as Aberfal – we could almost be in Wales. Cornish people are proud of their Celtic origins and Celtic saints dominate place names throughout the county, together with their associated tales of miracles. Apart from churches and ancient holy wells, there are sites associated with earlier pagan religions, their origins lost in time, which still come alive in the vigorous May time ceremonies associated with Padstow and Helston, for example. Finally, deep among the oak-lined banks of the drowned valleys of the Helford, Fal and Fowey rivers lie hidden creeks and villages, glorious springtime gardens and idyllic riverside inns. My list of gems would easily extend to two volumes!

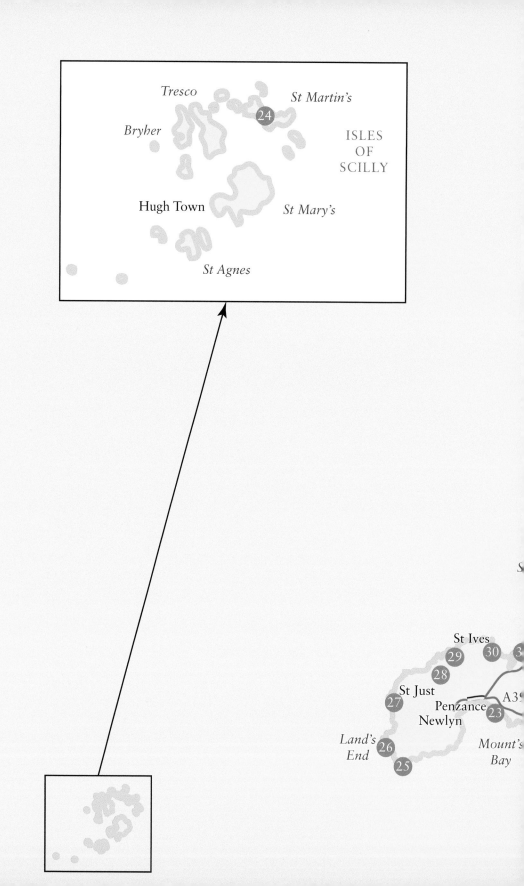

Tresco

St Martin's

Bryher

(24)

ISLES
OF
SCILLY

Hugh Town

St Mary's

St Agnes

St Ives

(29) (30) (3

(28)

St Just

(27)

A3

Penzance (23)
Newlyn

Land's (26)
End

(25)

Mount's
Bay

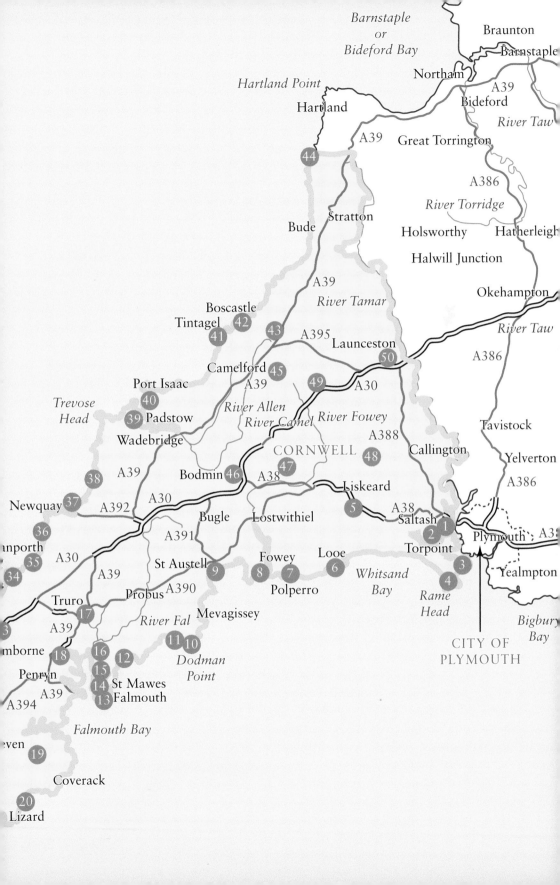

South Cornwall

1. The Royal Albert Bridge and Saltash Waterfront

What better place to start an exploration of Cornwall than beside Isambard Kingdom Brunel's iconic railway bridge spanning the Tamar and the border with Devon. It was completed in 1859, and was opened by Prince Albert only a few months before Brunel's death. It ended the isolation of Cornwall's railways and opened up the county to tourists. Recently a major refurbishment programme was carried out to extend its life. The bridge is best seen from Saltash waterfront, or get a closer view from the pedestrian walkway on the neighbouring road bridge.

I. K. Brunel's iconic rail bridge across the Tamar, seen from Saltash waterfront.

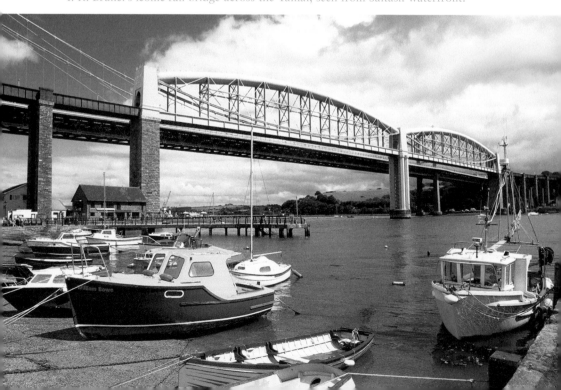

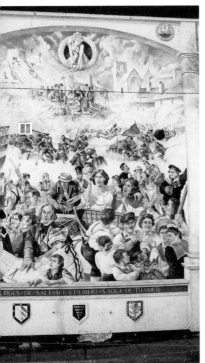
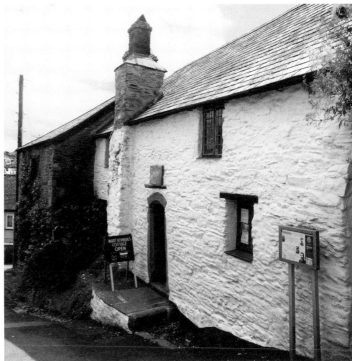

Saltash (left) mural by David Whittley, (right) Mary Newman's cottage.

The most distinctive building on the Saltash waterfront is undoubtedly the Union Inn, for its frontage is covered by a giant Union flag design, which can be seen from the far side of the river. On a side wall there is a splendidly detailed mural, called *History and Heritage*, depicting the military history of Saltash, the work of local artist David Whittley. A short walk up the hill from the waterfront brings us to Mary Newman's Cottage in Culver Road. The future wife of Sir Francis Drake, it is claimed that she lived in this cottage that dates from around 1480, the oldest building in Saltash. Some historians insist there is no evidence for this claim, and that she grew up across the water in St Budeaux. The cottage is run as a museum and inside there are displays of Elizabethan furniture and other domestic artefacts (loaned from the V and A). The Elizabethan herb garden at the rear affords a good view of Brunel's bridge.

2. Trematon Castle and Gardens

Cornwall is rich in castles, from prehistoric earthworks to the Norman keeps of Launceston and Restormel and the Tudor defences of St Mawes and Pendennis. Little cousin of Launceston Castle, Trematon is privately owned and until recently was only visible from afar.

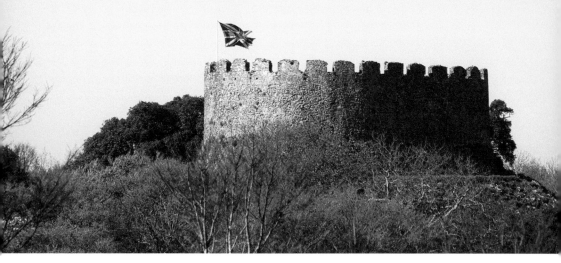

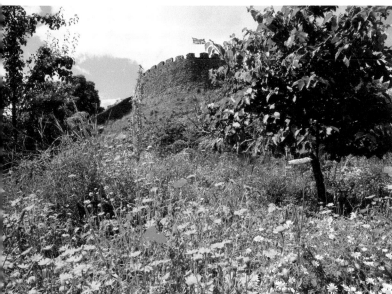

Built soon after the Norman Conquest by Robert de Montain, it was sold to Richard, Earl of Cornwall, in 1270 since when it has been owned by the Duchy of Cornwall, who lease it to its present occupants. The Grade I listed circular stone keep is perched on a hill overlooking to the south the estuary of the River Lynher flowing into the Tamar, and to the east the village of St Stephens, a suburb of Saltash. Below, the main railway line is carried across the Forder valley by one of Cornwall's many stone viaducts, and Sir John Betjeman described the panorama from the keep as 'one of the superb views of Cornwall'. During the sixteenth century Sir Francis Drake is believed to have stashed his Spanish treasure here. In the castle grounds is a large Grade II listed Regency manor house built by Benjamin Tucker in 1808. Since 2012, garden designers Julian and Isabel Bannerman have begun a rose garden in the grounds that will, they say, play to the castle's romantic and Pre-Raphaelite glories. The castle and gardens are open to the public from May to August, and the roses are at their best in June.

3. Kingsand and Cawsand

The twin villages of Kingsand and Cawsand overlook Plymouth Sound. There are records that these communities were raided by the Vikings in 813 and even joined forces with them to defeat the Saxon King Egbert. Kingsand is named after the Earl of Richmond (later Henry VII) who landed here before the Battle of Bosworth Field. A loyal supporter of the king was Richard Edgcumbe, who in 1547 built a large house, Mount Edgcumbe, nearby. Nelson is also said to have visited the Ship Inn before Trafalgar and the *Bellarophon* anchored offshore with a famous prisoner, Napoleon, on board. This led to a bonanza for local boatmen with a thousand boats taking sightseers out every day hoping to glimpse the notorious Frenchman. Up until 1844, when the county boundary was redrawn at the Tamar, Kingsand was in Devon. The old county boundary is still marked on the wall of Devon Corn cottage in Garrett Street.

There is ample parking at Cawsand and the walk to the beach takes us by pastel-washed cottages leading to the village square. Here we find the Cross Keys Inn, one of three pubs in the village, and a café surrounding an ancient cross. The beach looks across the Sound busy with shipping. A ferry runs from Plymouth to Cawsand in the summer, and the ferry shelter has an interesting tiled mural. The short walk up the hill takes us to Kingsand and its clock tower, which narrowly escaped being destroyed in a storm in 2014.

Cawsand beach.

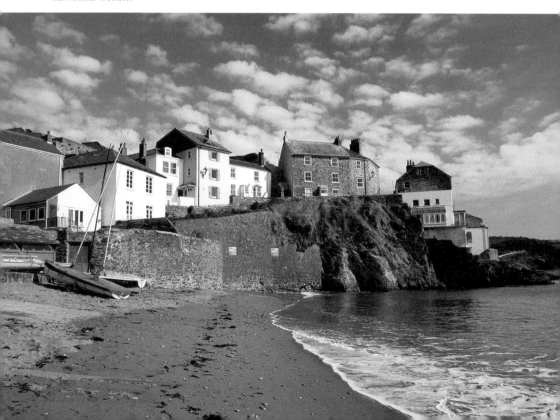

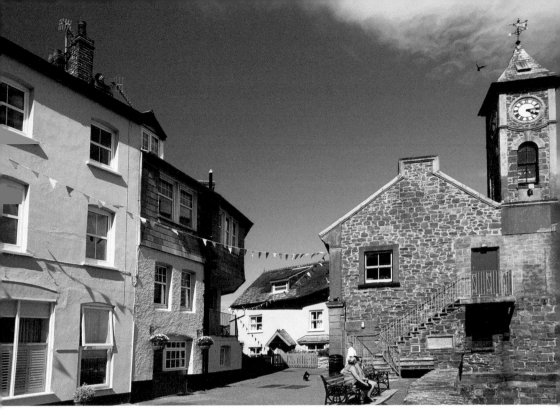

The clock tower, Kingsand.

Every May Day bank holiday the villages host the Black Prince Flower Boat Festival, which was revived in 1986, although it is thought to date back to the fourteenth century. Beginning in the neighbouring village of Millbrook, a model boat decorated with flowers, built by local boatbuilding apprentices, is carried by naval cadets around a route that ends up on Cawsand beach. Here it is towed out to sea accompanied by the strains of the Launching Song, a farewell to winter and welcome to summer. Town criers, folk bands and morris dancers add to the merriment.

4. Rame Head

Rame Head forms Cornwall's most southerly point until the Lizard at the south-western extremity of the peninsula. It has an unmistakeable conical shape topped by a fourteenth-century chapel dedicated, as hilltop chapels frequently are, to St Michael. From inside the building, an unglazed east window looks out to Penlee Point and on to south Devon. From the west doorway the view along the Cornish coast extends as far as the Lizard if the visibility allows. For walkers, the coast path from Cawsand takes us to Rame Head via Penlee Point, and if arriving by car there is parking at the end of a lane beside the thirteenth-century Church of St Germanus. This is itself worth a visit, having an unusual spire and no electricity connection, services being held by candlelight.

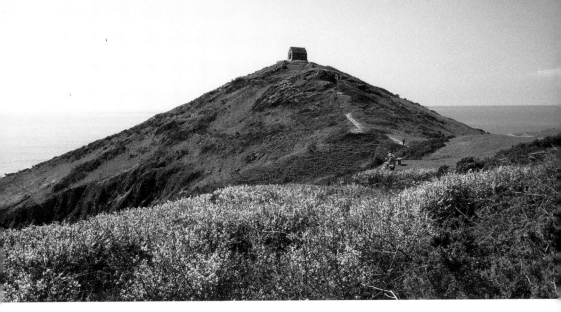

Above: Rame Head.

Below: St Michael's Chapel has views along the coast to Penlee Point into Devon.

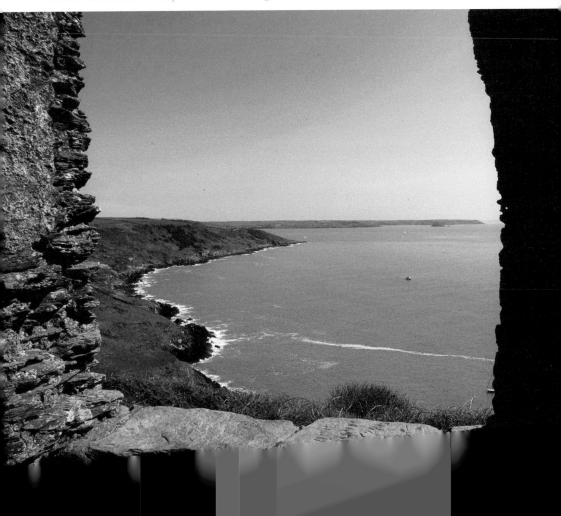

5. The Looe Valley Line

In 1966, the 9-mile branch line from Liskeard to the fishing port of Looe had a lucky escape from the Beeching axe when it was granted a reprieve from closure with just two weeks to spare. The line was opened in 1860 to replace an existing canal that had been in use for thirty-five years. A railway had already been constructed from the mines at Caradon to Moorswater, where the canal began. Initially the Looe branch was used only for mineral traffic, but in 1879 the first passenger trains were introduced. These also started at Moorswater, but in 1901 a link was built for the Great Western Railway Paddington–Penzance main line at Liskeard. This link forms the most distinctive feature of the branch, for it curves around in a complete circle while descending the 200 feet from Liskeard over gradients of 1 in 34 to the first halt at Coombe. Here the guard changes the points and the train reverses for the rest of the journey down the valley following the East Looe River. Liskeard station was a location in the 1941 film *The Ghost Train*, starring Arthur Askey and Richard Murdoch.

The line is noteworthy for having the only two stations in the national railway timetable with names ending in 'Halt' – in 1974 the powers that be had erased it from the railway timetable. St Keyne and Coombe Halts, both request stops, reverted to their original names in 2008. The line was designated a community rail line in 2005 as part of a government pilot scheme. Station signs were replaced by the old British Railways brown and cream colour scheme, and station shelters replaced with a more traditional design.

St Keyne Wishing Well Halt, and (inset) railway sign at Liskeard.

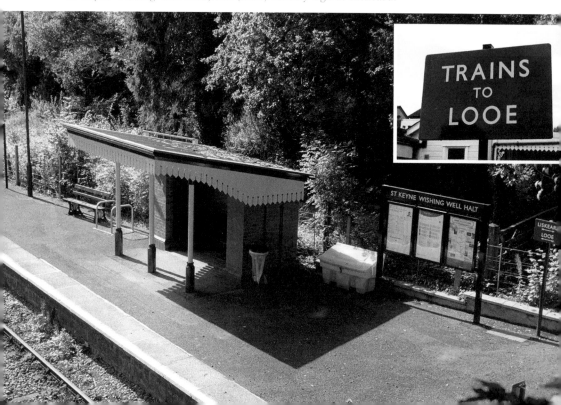

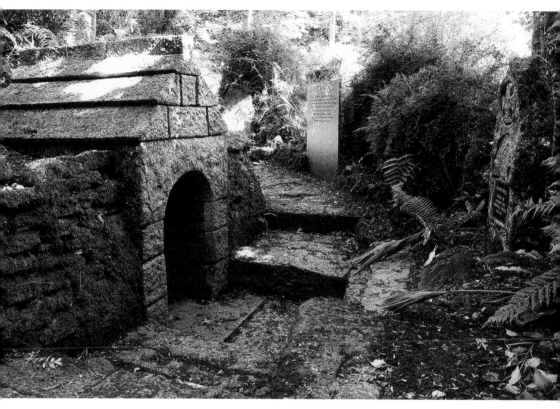

St Keyne Wishing Well.

After Coombe, the next stop is the romantically named St Keyne Wishing Well Halt. St Keyne was one of fifteen daughters of Braglan, a sixth-century Welsh prince. The legend says that on her deathbed she imparted magical properties to the water from the well, which is half a mile away from the station up a very narrow and steep hill. It is sheltered under trees in a mossy dell and nearby branches are hung with scraps of cloth, votive offerings showing that old superstitions still have power in modern-day Cornwall. The legend says that the first partner of a newly married couple to drink from the well after the wedding will have the upper hand in the relationship. During the nineteenth century, the story became popularised by the poet Robert Southey, and newly married couples would travel by train to the halt and then race up the hill to the well. The husband in Southey's poem was unlucky:

> I hasten'd as soon as the wedding was o'er,
> And left my good wife in the porch,
> But i' faith she had been wiser than I,
> For she took a bottle to church.

After the train passes Causeland and Sandplace, it reaches the tidal estuary, following the river to the little terminus station at Looe, one of the prettiest rail journeys anywhere in the country.

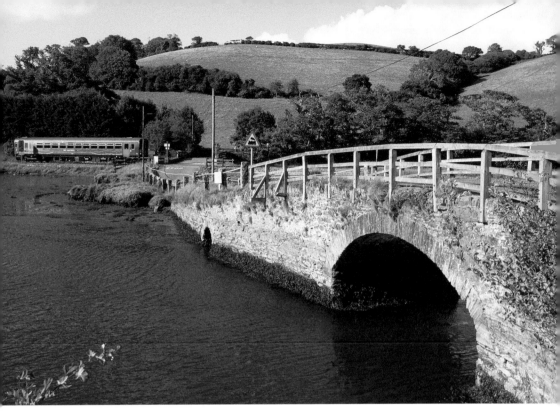

A train approaches the level crossing at Terras bridge on the Looe branchline.

6. St George's Island, Looe

Readers familiar with Enid Blyton's adventure stories will love the idea of a visit to a lonely island just off the Cornish coast. Looe, or St George's, Island is today owned by the Cornwall Wildlife Trust and inhabited by wardens who live there all year round. Its coastline is home to colonies of fulmars, black-backed gulls, oyster catchers and seals. Individuals born on the island are ringed or tagged and it has been shown, for example, that seals regularly travel to the island from as far away as north Devon. Today about one-third of the island is covered by broad-leaved woodland and this is mostly on the north side facing Hannafore, which affords the best mainland views of the island.

Up until 2004 the island was the home of the Atkins sisters, who bought it for £20,000 in 1964. People thought they were quite mad, but they loved the lonely existence, often being cut off for weeks during winter. Their experiences are told in two books: *We Bought an Island* and *Tales from Our Cornish Island*, copies of which can be purchased in the tractor shed, the island's version of a gift shop. When the last sister died in 2004 the island was gifted to the CWT, who organise boat trips to the island in the summer months. As with all boat trips from Looe, timings are dependent on the tides and, of course, weather. The crossing from East Looe takes around twenty minutes and each boatload of eleven passengers is met by the wardens

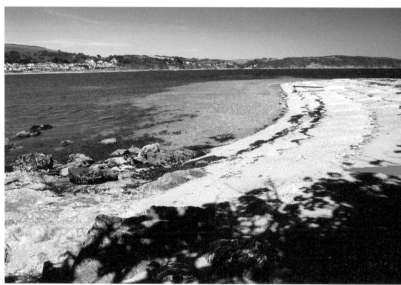

Above: St George's Island seen from Hannafore.

Right: The island's beach.

and given a short and informative talk about the history of the island and the wildlife found there. They also provide a map, since parts of the coast are off-limits to protect the wildlife. It is not easy to get lost since the island is only 1 mile around and can be covered by twenty minutes of brisk walking, although visitors are allowed two hours.

The island has been inhabited since at least Roman times, and a hoard of Roman coins were found in a recent *Time Team* television dig. It has been a place of Christian pilgrimage since medieval times when it was owned by Glastonbury Abbey. As at Rame Head, there was a chapel dedicated to St Michael on the highest point of the island, of which only a few stones now remain. When several pilgrims drowned while wading across the channel at the lowest tides, a second chapel was built on the mainland to make the journey less hazardous. In 1594 the island was rededicated to St George, after a warship of the same name, and became a haunt for smugglers; a cottage near the start of the trail is known as Smugglers' Cottage.

Smugglers' Cottage.

7. Lansallos

Little more than a few houses and a fifteenth-century church situated between Polperro and Polruan, Lansallos is reached via some narrow lanes leading off the East Taphouse to Looe road and has a shady National Trust car park. West Combe Cove has a fine shingle beach reached by a wooded path, which starts beside the church. Approaching the beach, the path goes through a narrow passage in the rock, which was possibly cut by smugglers. The coast path around here is worth exploring, and in the direction of Polperro we soon reach Parson's Cove where the local slate gives the cliffs a purple hue. The path then becomes a switchback with several steep sections, some of which are ascended by steps. In the other direction, west towards Polruan, we reach Pencarrow Head and Lantic Bay. This is a wonderfully quiet and secluded section of the Cornish coast amid typical rolling Cornish countryside.

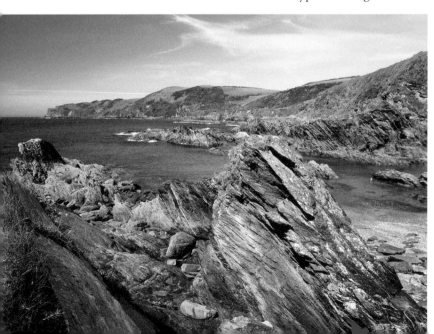

Parson's Cove and Pencarrow Head near Lansallos.

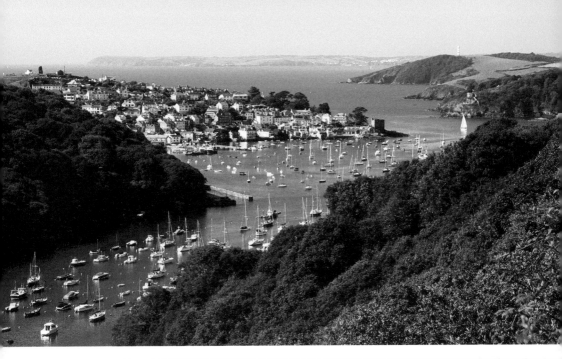

Above: Pont Pill and Polruan with Gribbin Head beyond.

Right: A quiet creek of the River Fowey at Pont.

As we near Polruan along the south bank of the creek, the terraced villas of Fowey across the water come into view, jostling for position along the rocky foreshore. Prominent among them is the Fowey Hotel, a tall and elegant Victorian building where Kenneth Grahame stayed when visiting Fowey. From his room he wrote letters to his sick son on hotel notepaper, and these tales of the riverbank later became the nucleus of his best-known book and are displayed in the hotel. On the brow of the hill above, shaded in trees, is Fowey Hall, said to be his inspiration for Toad Hall. At Polruan, a passenger ferry takes us back to Fowey.

9. Charlestown

Overlooking St Austell Bay, the Georgian port of Charlestown, formerly West Porthmear, was built in the 1790s to enable Cornish industrialist Charles Rashleigh to import coal and timber and export clay and copper from his local mines. At the time over a quarter of the world's copper was exported from this little harbour. Even if you have never visited, you will probably be familiar with its dockside and octagonal watch house, which have featured in numerous TV programmes and films, most recently *Poldark* of course. Scenes from *The Onedin Line, The Eagle Has Landed* and *Pirates of the Caribbean* have all been filmed here. Rashleigh's broad main street leads to the dock basin where sailing ships are usually berthed, overlooked by a row of colour-washed cottages each with a little wooden porch. Redundant chutes for the loading of china clay remind us that Charlestown was busy with coaster traffic up until the end of the twentieth century. The dock and village have always been privately owned, but thankfully its character has been maintained. It was recently purchased by Eden Project founder and keen diver Sir Tim Smit, who already owned the shipwreck museum, which displays artefacts recovered from diving expeditions on wrecks in the vicinity.

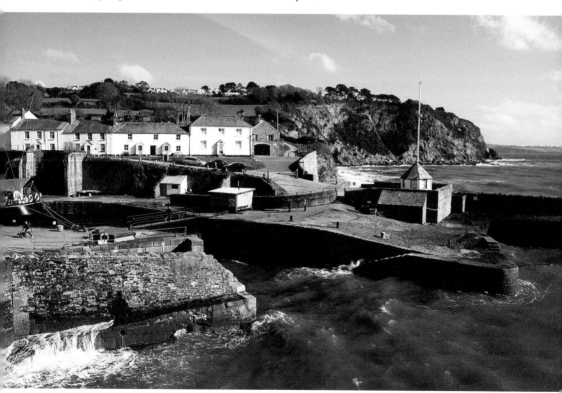

The harbour at Charlestown.

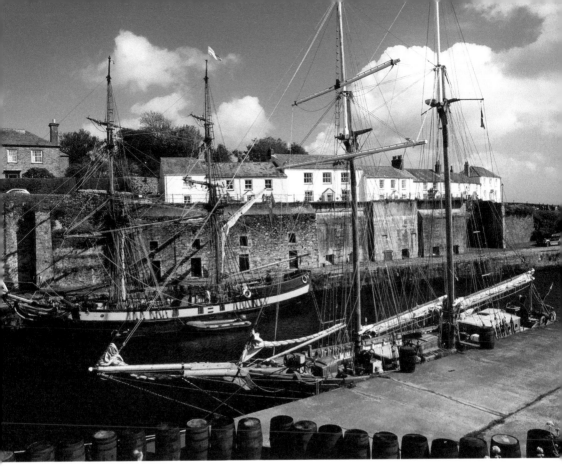

Above and below: Sailing ships at Charlestown.

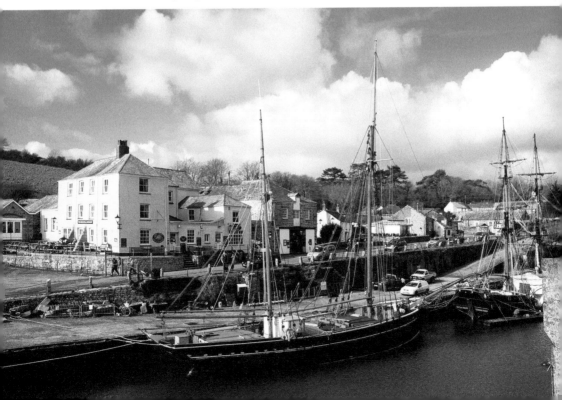

10. Gorran Haven and the Dodman

This is where I grew up, so I might be biased, but can there be a more perfect seaside village than Gorran Haven? Whitewashed cottages cluster around the safe sandy beach, giving way to pink-stained cliffs beyond. Smaller Little Perhaver beach adjoins it. Pilchard fishing was going on here in the Middle Ages when the village was known as Portheast, and more recently crabs and lobsters have kept a handful of full-time fishermen in employment. Today, there are mainly leisure boats moored in the lee of the harbour wall, built in the nineteenth century to provide shelter from easterly gales. Heading away from the beach is steep and narrow Church Street. It is lined by whitewashed cob cottages and the little fifteenth-century chapel of ease dedicated to St Just hides among them. In the other direction, there are a few shops and cafés and a house that has a blue plaque in celebration of amateur naturalist Charles Peach, a contemporary of Charles Darwin and friend of Tennyson. Peach was a coastguard here between 1834 and 1845. He discovered fossils in the local rocks, which had previously been thought too old to contain them.

Boats behind the protective arm of the quay at Gorran Haven.

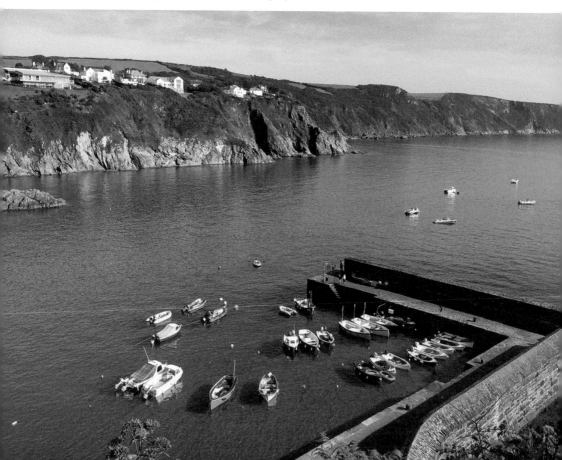

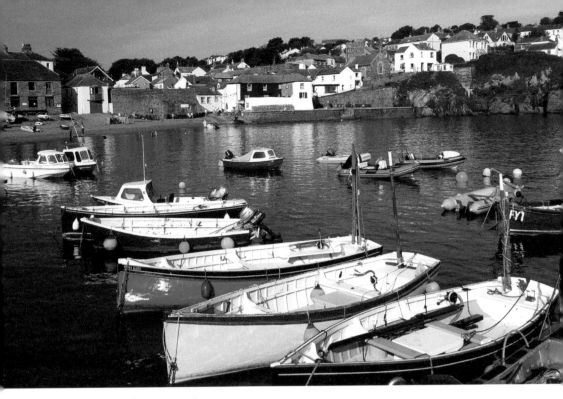

Above: Fishing boats at anchor.

Below: (Left) Steep Church Street, Gorran Haven, (right) the cross at Dodman Point.

For a bird's eye view of the village take the cliff path in the direction of Pen-a-maen Point to the south. Continuing along this path brings you to the mile-long Vault Beach and on to Dodman Point. The Dodman, or Deadman, to give it its more sinister name, is the most southerly point between Rame Head and the Lizard, and it has seen its share of shipwrecks and tragedies. The 15-feet-high granite cross was erected in 1896 as a statement of faith through the efforts of Revd George Martin, who was rector of the nearby village of St Michael Caerhays. A year later, in September 1897, two naval destroyers, the *Thrasher* and the *Lynx*, were wrecked on the rocks below the cross in a thick mist. A third vessel, the *Sunfish*, narrowly avoided the same fate. Three sailors lost their lives in the tragedy. A coastguard officer who ran the 2 miles back to Gorran Haven to raise the alarm also collapsed and died.

11. Caerhays Castle and Spring Gardens

For lovers of gardens, Cornwall is a dream location, especially in spring. The Lost Gardens of Heligan, Lanhydrock, Trelissick and Glendurgan all attract thousands of visitors every year. To this list should be added Caerhays, just 5 miles from Heligan and home to a Plant Heritage National Collection of Magnolias. Privately owned by the Williams family, a name familiar to lovers of camelias, this delightful castle

Caerhays Castle in spring.

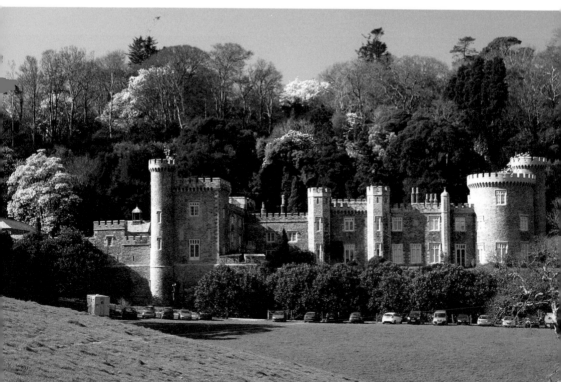

Magnolias bloom in profusion at Caerhays Castle and Spring Gardens.

was built in 1810 to a design by John Nash, who was also responsible for a slightly more famous palace on the Mall. At the time it was owned by the Trevanion family, but after they got into financial difficulties in the mid-nineteenth century it was purchased by Michael Williams, whose grandson John Charles began the planting of the gardens. He sponsored plant hunting expeditions to China and the Himalayas, led by such illustrious botanists as Ernest Wilson. The Williams family have been synonymous with azaleas, camelias and rhododendrons ever since, with successive generations seeming to have even greener fingers than their forebears! The gardens contain named hybrids from around the world totalling over 600 species.

The castle and gardens overlook Porthluney beach, a quiet cove to the west of Dodman Point. The castle is best seen when lit by the morning sun, and a splendid view is obtained from the coast path opposite. The gardens are normally open to the public during spring, and guided tours of the castle are also available. The best time to visit Caerhays is in March, when the magnolias are in full bloom; it is nothing short of glorious.

12. Veryan

The pretty village of Veryan near Nare Head is best known for its five round houses, circular white cottages, two pairs of which guard the road at each end of the village. They are complete with conical thatched roofs, and each roof bears a cross at the apex. They were built between 1817 and 1820 at the instigation of the philanthropic vicar Jeremiah Trist, and cost about £35 each. Now extended, one has recently been on the market for £625,000! A fifth, built slightly earlier, is hidden behind the school, and has a slate roof and a central chimney in place of the cross. The traditional explanation for their design is that they were built to scare off the Devil, the circular interiors providing no corners for him to hide in. They were actually

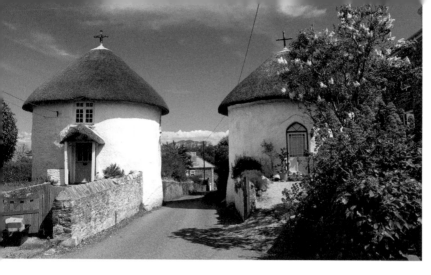

intended as cheap labourers' cottages, and based on a design by Vice Admiral Charles Penrose, who had one built on his estate near Lostwithiel. The plan was published in George Worgan's Agricultural Survey of the county in 1811, which Penrose and Trist worked on together. Two more modern round houses can be found behind the church, incorporated into the design of Homeyard Homes, built in the 1950s as part of a legacy to provide retirement homes for widows of seamen. The benefactor was Maria Kempe Homeyard, whose grandmother came from Veryan. She and her husband made a fortune from the sales of Liqufruta cough syrup, which he invented and which was very popular in the early 1900s.

Veryan's Church of St Symphorian is in the centre of the village beside a pretty water garden. In the churchyard is what is believed to be the longest grave in the country, a memorial to fifteen sailors who were buried here following the wreck of the *Hera*, which came to grief off Nare Head on the night of 31 January 1914.

St Symphorian's, Veryan.

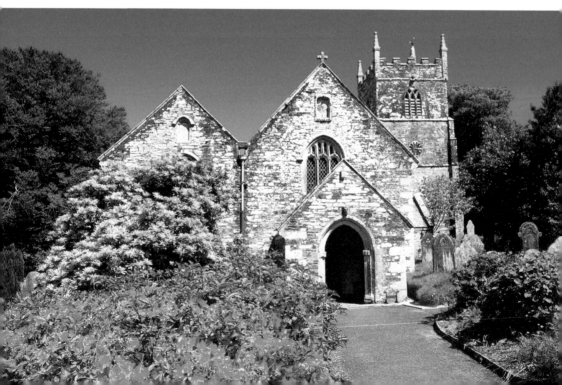

13. St Anthony-in-Roseland

Beyond Veryan, narrow lanes take us towards St Anthony-in-Roseland, the name that drew H. V. Morton on his motoring trip around the country in 1926. In his book *In Search of England* Morton describes the sunken lanes overhung with trees leading to the village, and in this respect nothing has changed. St Anthony itself is dominated by Place Manor, a large Victorian house set among lawns looking across Percuil Creek to St Mawes, to which it is connected by a passenger ferry. Place is the seat of the Spry family, which was built on the site of a priory once afforded cathedral status by King Athelstan. The adjoining twelfth-century Church of St Anthony has a magnificently carved Romanesque Norman doorway. Some have interpreted the pictograms carved within the arch as telling the story of Christ visiting Cornwall with his uncle (*see* St Just-in-Roseland). Morton makes no mention of Place, since he actually stayed in the adjoining hamlet of Bohortha and probably never saw it. At St Anthony Head is a lighthouse built in 1835 to warn of the dangerous rocks between St Anthony and Falmouth. The coastal views from here across the estuary to Falmouth and St Mawes are magnificent, and the walk around Carricknath Point through stands of Monterey pines to Place has great views across to St Mawes and its Tudor castle.

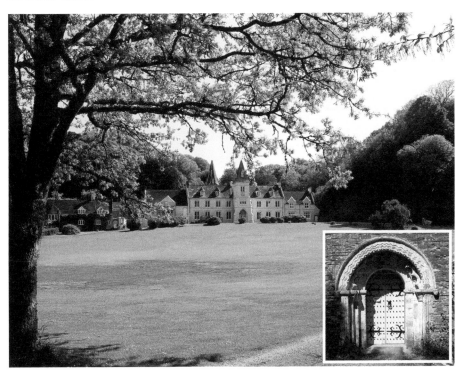

Place House, St Anthony-in-Roseland, (inset) the Norman doorway of the church.

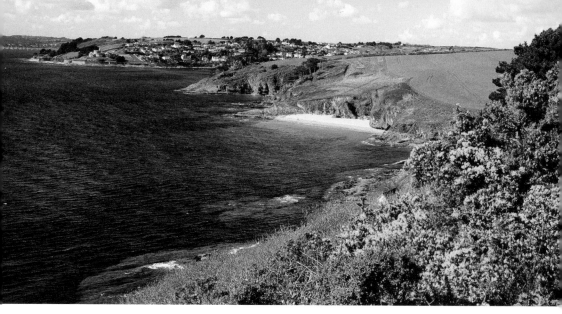

The view from St Anthony Head.

14. St Mawes

The largest village on the Roseland, St Mawes has an idyllic setting with views across Percuil Creek to Place and St Anthony. Its treasure is a well-preserved Tudor castle built by Henry VIII, whose name is inscribed on the walls. Under threat of attack from France and Spain, Henry ordered the building of a chain of fortresses along the south coast including this one at St Mawes and another across the mouth of the Fal at Pendennis. The story that Henry and Ann Boleyn spent part of their honeymoon

A ferry passes St Mawes Castle, built by Henry VIII.

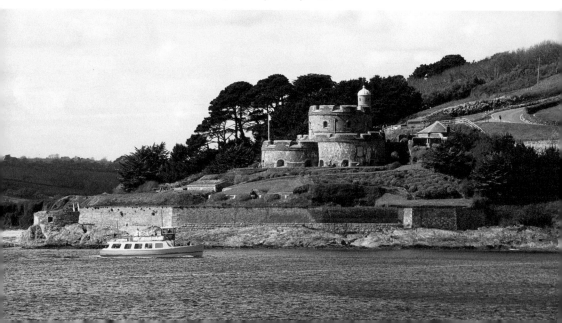

Cottages along the waterfront.

at the castle in 1535 cannot be true, since the castle was not built until eight years later. It is constructed on a clover-leaf plan with three smaller bastions connected by staircases to the central tower. In Henry's day up to 100 men would have been stationed here, with more being drafted in if needed. Today, from the terraces, the visitor can see from St Anthony Head on one side to the port of Falmouth and the Cornish coast towards the Lizard on the other, with Pendennis Castle outlined against the sky. A short walk from the castle brings us past thatched holiday cottages and the modest frontage of the exclusive Tresanton Hotel (owned by Olga Polizzi) to the busy harbour, where the comings and goings include regular passenger ferries to Falmouth and Place, as well as a summer ferry service to Trelissick. Kayaks and self-drive boats can be hired for those who fancy exploring the creeks of the Fal at their leisure.

St Mawes harbour.

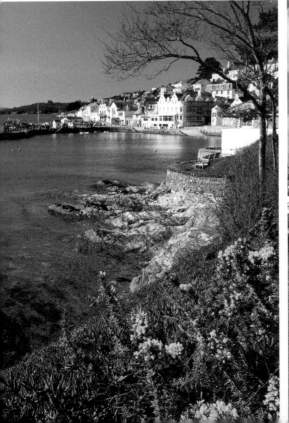

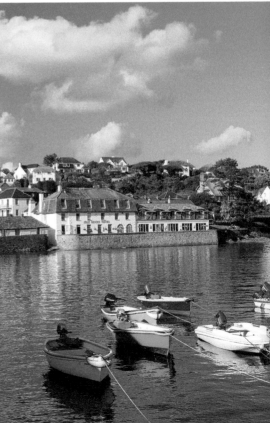

15. St Just-in-Roseland

A few miles from St Mawes, St Just-in-Roseland is justly famous for its ancient church set in a subtropical garden beside a creek. The signpost points to St Just Church and Bar, referring to the sand bar, not a riverside inn! The church has its origins in Celtic times, but the present church was consecrated in 1261. In common with other parts of the south Cornwall coast, legend says that Christ came in a ship and anchored in St Just creek, accompanying his uncle Joseph of Arimathea, who

Left and below: St Just-in-Roseland church beside a creek of the River Fal.

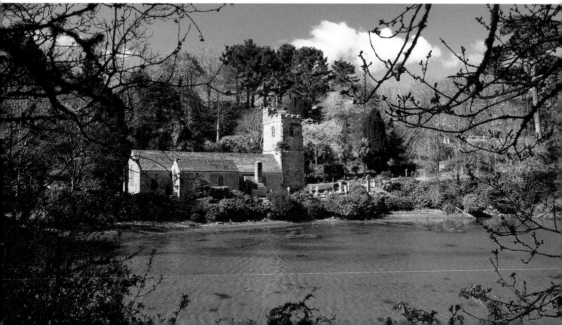

traded in tin. A modern Celtic cross overlooks the creek, a memorial to Sir John Bowen Cooke, chief mechanical engineer of the LNWR, who died in 1920. There is also a wooden seat inscribed to the memory of William Hosier, who was killed flying a replica Supermarine S5 seaplane from this creek in 1987.

The writer H. V. Morton visited here in 1926 after staying at St Anthony, and was transfixed by its beauty, calling it 'a Garden of Eden that cannot be described in pen or paint'. He spoke to the rector who was tending the plants, almost certainly Humfrey Davis, the incumbent between 1901 and 1930. Davis was responsible for much of the planting and the many stones that line the paths on which are inscribed verses from scripture and poetry. In spring the paths are lined with rhododendrons and azaleas, and the view through the lych gate gives us a classic view of the church tower amid the luxuriant foliage with the blue waters of the creek beyond. No wonder that it has been called the most beautiful churchyard in England.

16. King Harry Ferry and Feock

From St Just, signposts direct drivers to the *King Harry* ferry, which takes cars across the Fal from the Roseland to Feock, and hence to Truro. This watery shortcut saves drivers a journey of 26 miles through winding lanes, and has been voted among the world's top ten ferry crossings. The ferry is guided by chains and is thought to have

The *King Harry* ferry.

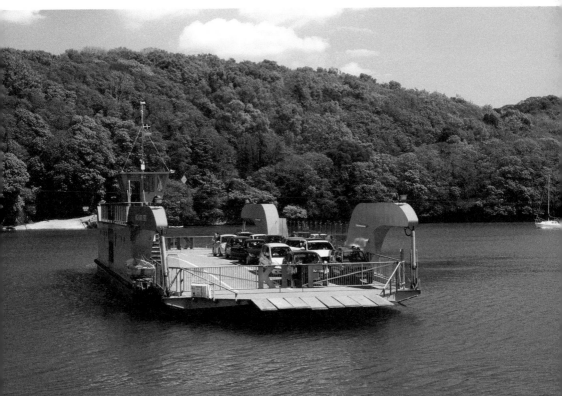

got its name because it originally served a chapel dedicated to Henry VI, making it one of the oldest ferry crossings in the country (the chapel is no longer in existence). Morton put forward another theory: that Henry VIII swam his horse across here to impress Anne Boleyn. On each side of the river here are two great estates, both with magnificent gardens. On the western side at Feock is Trelissick, now in the care of the National Trust. On the Roseland bank is Tregothnan, the house dating from 1652 and still privately owned by the Boscawen family. Tregothnan is the only place in Britain where tea is grown – camellias have long flourished in this part of Cornwall, so it should not be too surprising to find the tea plant also enjoys the climate. Despite its tranquil setting, this remote creek is a barometer of the world economy. The very deep water of this part of the Fal makes an ideal anchorage for shipping, and is used to mothball tankers, ferries and cruise ships that have become surplus to requirements.

The pretty village of Feock overlooks the river and has an unusual church with a separate bell tower. It is at its best in spring when the magnolias are in bloom. Another unusual place of worship is found a mile away at Come-to-Good. The Friends Meeting House was built here in 1710 and has been in continuous use for more than 300 years. It is a thatched barn-like building that has an adjoining stable or linhay with a catslide roof, added around 1800. Inside it is simply furnished with wooden benches and a gallery. Guidebooks will tell you that the name Come-to-Good derives from the Cornish for 'House in the Combe', but recent research suggests a more literal derivation since it has only been in use since 'Friends' began meeting in the locality.

Spring in Feock churchyard.

Friends Meeting House, Come-to-Good.

17. Truro

Truro was granted city status in 1877. The town was originally granted a charter during the twelfth century, and grew up where the rivers Allen and Kenwyn merge to form the Truro River. This is a tributary of the Fal, and Truro was an important port for many centuries: river traffic only ceased during the last century as the river silted up. Today tourists can take boat trips to and from Falmouth but boats can only reach the quay at high tides; at low tides passengers have to embark a mile or so downriver at Malpas (literally 'dangerous crossing') where the channel is always navigable.

Tin had an important influence on Truro's development, especially during the eighteenth century. As far back as 1351 Truro had a coinage hall and hence held the status of a stannary town. The practice of coinage was a form of taxation, in which the corner or 'quoin' of each tin ingot produced was sliced off. The practice was discontinued in the mid-nineteenth century, when the hall was replaced by a Victorian building, still called the Coinage Hall, which survives today. It currently houses a Victorian-style tearooms, which are well worth a visit. Boscawen Street is exceptionally wide and spacious because of the demolition of a middle row of shops, and the road surface still retains its granite cobbles or setts. Dominating the street is the Italianate City Hall of 1846, which now houses the Hall for Cornwall, Tourist Information and Mayor's Parlour.

Wealthy mine owners chose to build their grand houses in the town, architectural styles favouring the example of Bath. Truro's Assembly Rooms were built in the late 1780s in High Cross and boasted a theatre. The handsome pedimented front is still

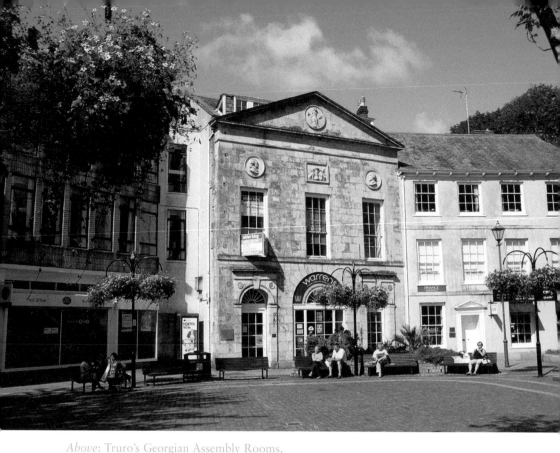

Above: Truro's Georgian Assembly Rooms.

Below: Truro (left) statue of Richard Lander, Lemon Street, (right) Coinage Hall.

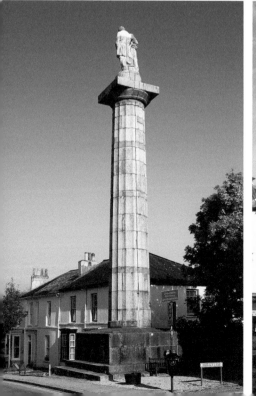

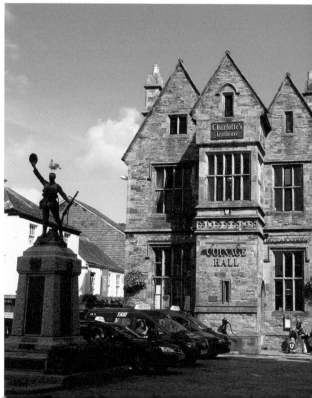

preserved adjacent to the west front of the cathedral. It is decorated with plaques containing cameos of Shakespeare and Garrick, although today these adorn the fronts of more mundane businesses.

Lemon Street is considered by some to be the finest Georgian street west of Bath. Broad and spacious, it ascends a hill to the south on the old road to Falmouth. At the top of the street is a tall Doric column with a statue sculpted by Neville Northey Burnard (*see* Altarnun) erected in memory of Richard Lander. He sailed to the West Indies in a merchant ship and in 1830 organised an expedition to explore the River Niger by canoe, naming an island after his hometown. He was awarded the first ever Gold Medal from the Royal Geographical Society in 1832.

In 1876 the diocese of Truro was created and the building of the country's first protestant cathedral since St Paul's began soon afterwards. Elevated to city status, Truro's development as the cultural centre of Cornwall was assured. Most visitors are surprised to learn that the cathedral is only just over 100 years old; in style it appears much older, borrowing heavily from medieval Gothic. The architect John Loughborough Pearson had travelled extensively in France and this is evident in the three Normandy Gothic spires, dedicated to Queen Victoria, Edward VII and Queen Alexandra. Truro was the scene of an ecclesiastical first in 1880 when Bishop Benson introduced the service of nine lessons and carols, now a tradition in the Anglican church. It was not held in the present building, however, but in the temporary wooden cathedral that was used for worship until the nave roof was completed in 1887.

Truro Cathedral west front (left) and east front (right).

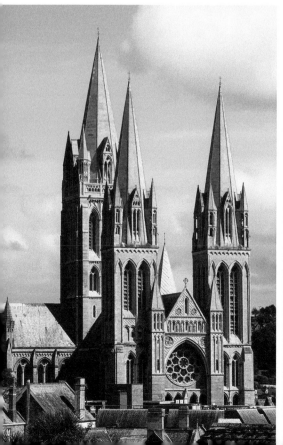
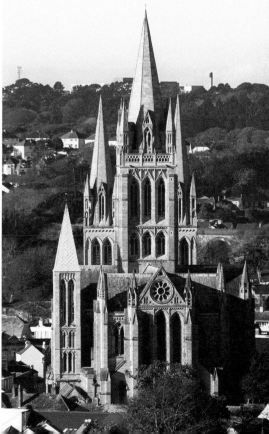

18. Enys Gardens

Enys is hidden away in the back lanes between Perranarworthal and Penryn, on the Mylor road. The estate has been owned by the Enys family since Norman times. It is open between April and September, but only on certain days of the week. It is a gem because it boasts the best display of bluebells in the county, peaking in mid-May, the best time to visit – the website has updates about them. The bluebells cover an area of tree-lined meadow, Parc Lye, and are a stunning sight when at their peak.

A spectacular display of bluebells at Enys Gardens.

19. Helford Village and Frenchman's Creek

Like the River Fal, the Helford is a flooded valley or ria that all but cuts off the heel of Cornwall just south of Falmouth across to Helston. Popular with leisure sailors, it is much less explored by the motorist, possibly because of its remote setting reached by a maze of narrow lanes. The village of Helford, on the south bank, has a quiet charm, and is well worth the ascent down the narrow winding hill to the car park. In summer it can also be reached from Helford Passage, on the north bank, from where an on-demand ferry service operates, wending its way among moored

Helford village.

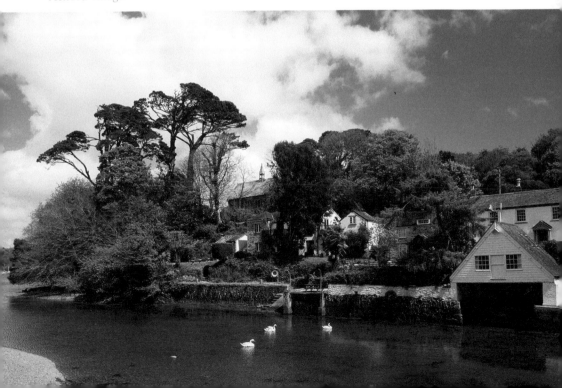

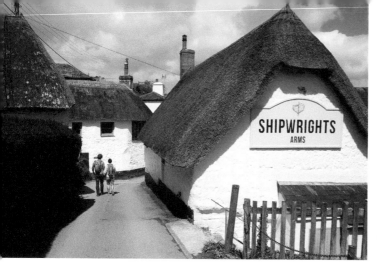

The Shipwrights
Arms, Helford.

yachts for which it also provides a taxi service. Helford was once an important port
trading in French rum and tobacco, and during the Napoleonic Wars offered shelter
to smugglers and pirates. The village borders a sleepy creek and has a number of
thatched cottages, a shop and a thatched inn, the Shipwright's Arms, opposite which
a footpath heads off towards Frenchman's Creek. Best visited at high water, when
its quiet stillness is only broken by the cries of birds and the occasional splash of
a canoe paddle, the creek's tree-lined banks are off limits to cars and can only be
reached on foot or by kayak or pleasure boat. In 1932 Fowey author Daphne du
Maurier spent her honeymoon here and found the inspiration for her buccaneering
novel *Frenchman's Creek*, which is set in the reign of Charles II.

Peaceful Frenchman's Creek.

20. Cadgwith Cove

Just east of The Lizard, Cadgwith is no Cornish honeypot fishing village. Lacking a harbour, the boats are winched out of the sea up to the top of the pebbly beach. The cove has a working air about it, with tractors, mooring ropes, lobster pots and fish crates all much in evidence. Nonetheless, it manages to be extremely photogenic. Cottages are predominantly thatched, the thatch held down by chains to prevent damage by storms. The pilchard cellars are no longer used for their original purpose, the fishery having declined since the 1950s. In 1904 a record number of the fish were landed here, almost 2 million over four days. Today crabs and lobsters are the main catch.

The walk from the car park takes us down a valley to the village, between back gardens and passing the little blue painted corrugated-iron tin tabernacle church. A classic view of the village can be obtained from the Todden, a grassy plateau overlooking the beach. To the south of the village beside the coast path to the Lizard is the Devil's Frying Pan, a deep collapsed cave.

Thatch at Cadgwith.

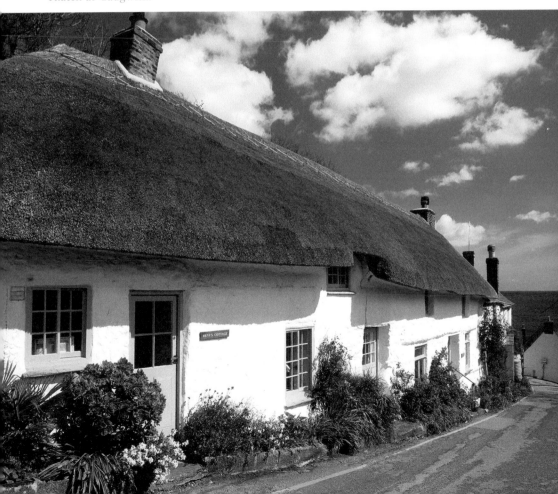

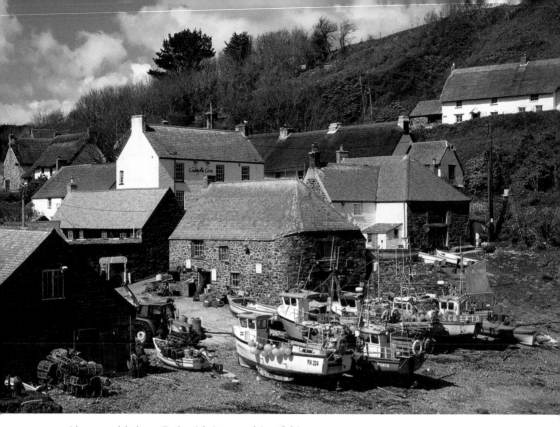

Above and below: Cadgwith is a working fishing cove.

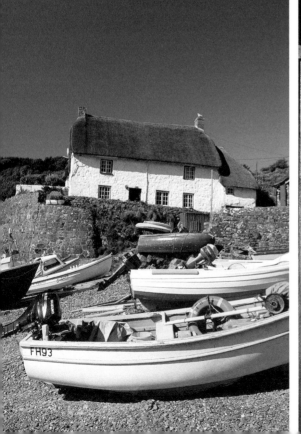

THE CADGWITH
FISH SELLER
OPEN 3·00 - 6·00 pm
MONDAY - FRIDAY
FRESH
BASS FISH BRILL
TURBOT, LEMON, MEGRIM
HADDOCK, HAKE, PLAICE
MONK, SCALLOPS, MUSSELS
JOHN DORY, SQUID, RAY
SAMPHIRE

21. Kynance Cove

There is nowhere better to view the serpentine rock that forms The Lizard peninsula than at Kynance. Lying on the west coast of The Lizard directly opposite Cadgwith on the east, the sea has eroded the serpentine cliffs to form a series of islands with imaginative names like Sugarloaf Rock, The Bellows and The Bishop. The most prominent is the flat, grassy-topped Asparagus Island, so named because wild asparagus grew there. The beach with its many nooks and crannies is popular with visitors but gets crowded at high tide. It can be safely explored at low tide, when the white sand surrounding the islands is exposed, but care should be taken when the tide is coming in since it is easy to get cut off. Kynance can be reached by car via a private road leading to the National Trust car park, but my favourite approach is to take the cliff path north from Lizard Point.

Serpentine is a soft rock related to soapstone and is easy to work, and local craftsmen on The Lizard still use it to fashion objects such as table lamps as souvenirs. It is also quarried as a building material, and between Kynance and Mullion, at Gew Graze (nicknamed Soapy Cove), there is an outcrop of soapstone that was quarried and sold for use in the manufacture of soft paste porcelain. This quarry closed in the early nineteenth century.

Below and overleaf: Serpentine scenery at Kynance Cove.

22. Helston Flora

Flora Day is among the best known of Cornwall's springtime revels, helped by the popular song based on the event, which was recorded by Sir Terry Wogan in 1978. Its composer Katie Moss visited Helston in 1911 and wrote the song after hearing the catchy tune that accompanies the dancing. The Flora, or Furry Dance (derived from the Cornish word 'fer' meaning 'a feast'), is believed to date back to pre-Christian times. Its pagan origin will not be evident to those who only observe the more formal dances, which begin with the early morning dance at 7 a.m., but is obvious to observers of the Hal-an-Tow, a traditional mumming play performed at various locations in the town beginning an hour and a half later. Figures clad in greenery, gathered during dawn forays into the woods, mix with a cast of characters who proceed to enact events from both Cornish and English history and folklore. This is accompanied by the Hal-an-Tow song, which celebrates the coming of summer:

> Hal-an-Tow, Jolly Rumble O!
> For we are up as soon as any day O,
> And for to fetch the Summer home,
> The Summer and the May O
> For summer is acome O
> And Winter is a gone O!

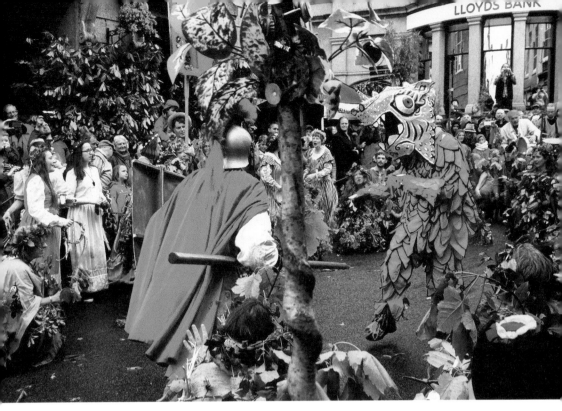

Above: St George fights the dragon, Hal-an-Tow, Helston.

Below: The Midday Dance, Helston Flora.

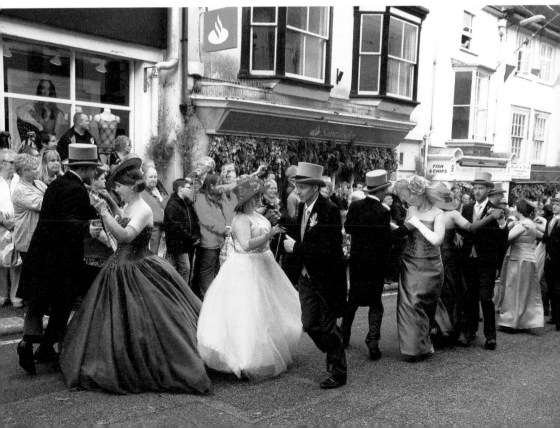

After the raucousness of the Hal-an-Tow, the children's dance that follows at 10 a.m. is in delightful contrast with the children dressed in white, wearing the traditional sprig of Lily of the Valley in their buttonhole. The girls wear headdresses woven from garlands of flowers, the colour of which signifies which school they attend. Led by the band, they dance through the streets in pairs, youngest first, the whole procession taking perhaps twenty minutes to pass. When the children have finished, excitement begins to mount as the midday dance approaches. When the Guildhall clock strikes twelve the lead dancers emerge from inside to begin the Principal Dance of the Day. The cue to begin comes from the 'big bass drum' as the band strikes up the familiar tune. Unlike in the popular song, this is a brass band and there are no fiddles, cellos, flutes, or clarinets, but plenty of cornets and euphoniums. The musicians have this music in their blood, and play the tune at a brisk pace, taking about an hour and a half to complete the route. The midday dancers dress formally, the gentlemen in morning dress and the ladies in colourful and elegant ball gowns and hats. As the procession makes its way along the narrow streets, the dancers weave in and out of shops, offices and banks, sometimes entering through one door, then going around the back and exiting through the front of the shop next door, all the time remembering to smile at the watching crowd! Leading the dance is an honour afforded only to people born in the town. Flora Day is held every 8 May, unless that date falls on a Sunday or Monday, when it is moved to the preceding Saturday.

23. St Michael's Mount

Whether seen through early morning mist from Penzance harbour, surrounded by the glittering sea from the train, or as a silhouette against the evening sky over Mousehole, the outline of the magical Mount never ceases to captivate. With its castle appearing to grow seamlessly from the granite rock itself, it has become a magnet for tourists from all over the world; nowhere else in the county have I heard such a diverse collection of languages and accents among the throng of visitors. Stunningly located in the sweep of Mount's Bay, the romantic outline just offshore beckons all who come to either walk across the causeway, or if the tide is high climb aboard one of the fleet of boats which buzz busily to and from Marazion to the Mount. The ancient abbey and church were built in the twelfth century by monks from its companion isle in Normandy, Mont St Michel. The church we see today was rebuilt in the fourteenth century following an earthquake. After the French wars, in 1424 it was gifted to the Brigittine nuns of Syon Abbey. Owned by the Crown after the dissolution, it was acquired by the St Aubyn family in 1659 who still live there today, although the island is owned by the National Trust. Further additions were made in 1875 and as recently as 1927, these being sympathetically designed to complement the medieval building they adjoin. In the early twentieth century a tramway, now powered by electricity, was built to move goods from the harbour up to the castle through a tunnel excavated by Cornish miners. A modern transport link

is the bespoke amphibious vehicle *St Michael*, which is particularly useful in winter. There have been frequent royal visitors, some of whom have left footprints in the concrete among the cobblestones around the harbour: compare the size of your feet with the Queen and the Duke of Edinburgh's, the Duke of Cornwall's, or the tiny feet of Queen Victoria on the eastern pier.

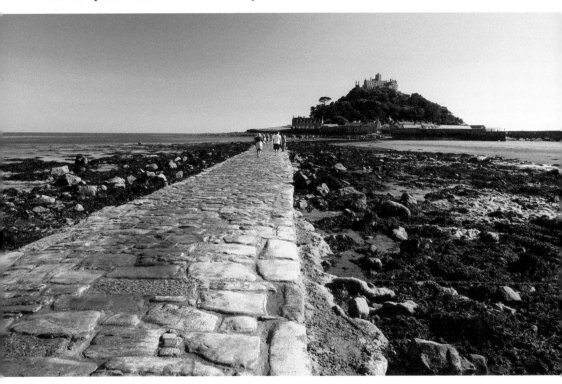

Above: The granite causeway to St Michael's Mount is revealed at low tide.

Below: St Michael's Mount from the sea.

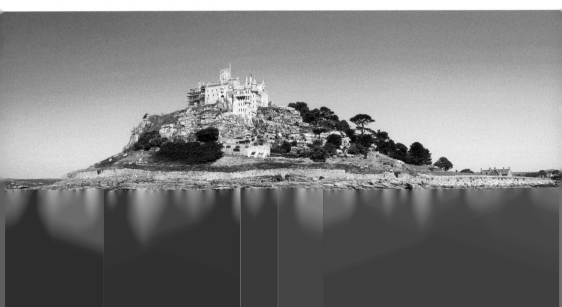

24. St Martin's, Isles of Scilly

The Isles of Scilly lie 28 miles west of Land's End and are made up of some 140 separate islands, most of which are barely more than ledges of rock. Only five are inhabited: St Mary's (the capital), Tresco, St Agnes, Bryher and St Martin's, any one of which qualifies as a gem, so I apologise to aficionados of the other four.

There are two alternatives to reach the Scillies: three hours on the *Scillonian* ferry from Penzance, or less than thirty minutes on a small plane from Land's End airport, weather permitting. Flights also go from Newquay and Exeter airports, and a helicopter service is being planned at the time of writing. Flying from Land's End is an experience that you will either love or hate: the plane is tiny and you can watch the instruments over the pilot's shoulder. The view of the Cornish coast and the approach to St Mary's is spectacular and worth the fare on its own. A short boat hop takes visitors from St Mary's to St Martin's. It is astonishing how a boatload of thirty or more people can land on the island and disappear completely within the space of a few minutes, only materialising again when the boat returns for the pickup later in the day.

A white sandy beach on St Martin's, Isles of Scilly.

Higher Town Bay, St Martin's.

Most landings are at Higher Town, no more than a few cottages and a farm overlooking a white sandy beach. It has a bakery, tearooms and an art gallery. To the east a path goes to the daymark, a red and white banded beacon erected in 1683. To the west the tarmac road passes the fire station and school and down the hill to Middle Town, where a stop is recommended at the Sevenstones Inn, advertised as the 'pub with the best view in the world'. Who am I to disagree: the terrace looks out over a wide sandy expanse called the Neck of the Pool across turquoise blue water towards the white sandy beaches of Tresco opposite. If you can tear yourself away, it is a short walk down to Lower Town where there is a luxury hotel, the Karma, looking across to the island of Tean and in the distance Round Island lighthouse. The subtropical climate means that in the summer the island is dotted with blue agapanthus and the incredible succulent Aeonium 'Schwarzkopf', which has flowers that are almost black.

25. Porthcurno

One of Cornwall's best beaches, it is made of fine white sand composed of ground up shells, an unusual museum and a world-famous cliffside theatre. The beach harbours a secret beneath the sand, a clue to which is found behind the car park in the form of the Telegraph Museum. Since 1870, Porthcurno has been the terminus for thousands of miles of undersea cable, which comes ashore under the beach; it was considered that this quiet location would reduce the chances of the cables being damaged by shipping. At the top of the beach is a concrete hut in which the cables once terminated. If you squint through the iron grill you can still see the old terminals bearing labels with their point of origin; Gibraltar and Lisbon were among the first to be connected. The museum used to be a training centre for telegraphers, which was closed in 1970, and most of the houses in the village were built as accommodation for the technicians. The museum houses hands-on displays that tell the story of communications from the early cables to the fibre optic versions that still run under the sand today.

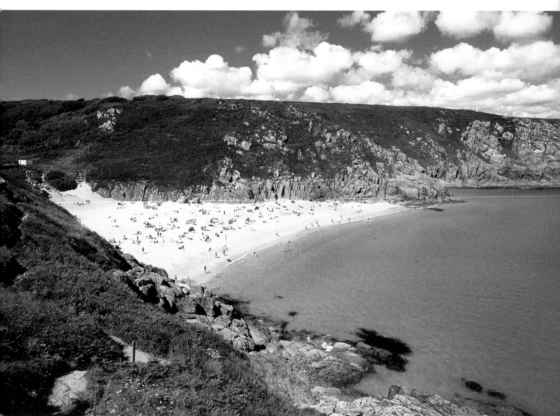

Porthcurno.

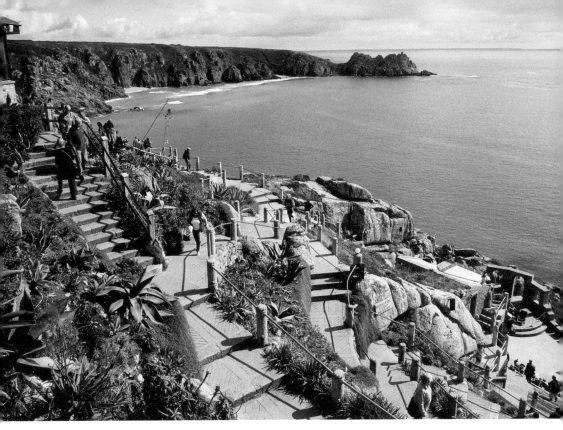

The Minack Theatre.

If from the beach you can hear some distant music it might be coming from the Minack Theatre, carved into the cliff just up the steep cliff path to the west. In the 1920s its founder Rowena Cade owned a house on the cliff here and her interest in amateur dramatics led her to organise a production of *A Midsummer Night's Dream* in her garden overlooking the sea. With the help of her gardener she made a terrace and some rough-hewn seats, which they gradually extended each year. Today it has become one of the most unusual theatres in the world, open from April to September, the stage boasting what must surely be the finest backdrop anywhere, the turquoise waters off Porthcurno with the rocky promontory of Treryn Dinas in the distance.

26. The B3306 between Land's End and St Ives

I love the B3306 as it winds its way around the westernmost coast of Cornwall's toe. It is bounded to the south by the wonderful white sands of Sennen Cove, and to the north by the equally stunning beach of Porthmeor beside the Tate gallery in St Ives. In between there are some of the rockiest granite cliffs in Britain, but almost

no beaches to speak of. I recently discovered the best way to enjoy the view: from high up on the open top Atlantic Coaster bus. These buses cover a triangle between St Ives, Land's End and Penzance during the summer months. The A3 route begins at Land's End and you can hop on and off wherever you fancy. Descending the hill into Sennen gives stunning views of the turquoise blue waters set against the sugar-white sands of the cove. Then the route passes Land's End airfield, where flights come and go to the Isles of Scilly. After a stop at St Just, we reach the old tin mines of Botallack and Levant before calling in at the Geevor Tin Mine museum. As we continue north past Pendeen towards Morvah, the granite moors of West Penwith rear up as if a piece of Bodmin Moor had been broken off by some giant and thrown into the sea. Bracken-covered slopes sweep down from the rocky summits strewn with prehistoric barrows and standing stones. The bus squeezes its way round corners between granite cottages and occasionally has to reverse for oncoming traffic, including the bus coming the other way! After we pass the ruined engine house of Carn Galver Mine at Rosemergy, the coastline can be seen in a great sweep as we climb away from Zennor towards St Ives. The Atlantic Coaster timetable is available from the First Kernow website.

The ruins of Carn Galver Mine, seen from the open-top 'bus'.

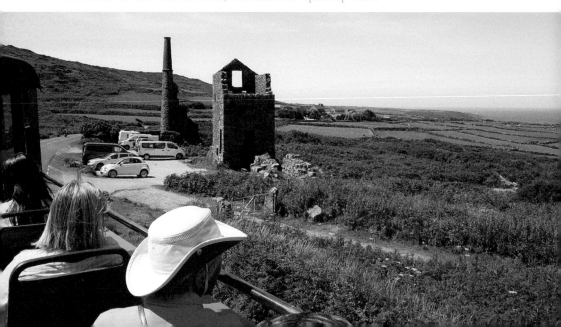

27. Botallack

All along this so-called 'tin coast' there are reminders of Cornwall's mining past, and at the foot of the cliffs at Botallack a pair of ruined engine houses can be found, which are most iconic of all: Crowns. The lower structure, which sits almost at sea level, held a pumping engine and the higher one a winding engine. These served tunnels stretching for half a mile out under the sea bed, which produced a total of 14,500 tons of tin, 20,000 tons of copper ore and 1,500 tons of refined arsenic up until mining ceased here in 1895 after a collapse in the price of these metals. Further up the cliff are the now ruined calciner buildings, which processed the arsenic in what must in its heyday have been a scene of toxic horror. Nearby the ruins of Wheal Owles can be found, where in a terrible disaster in 1893 nineteen miners were killed after part of the mine was flooded following a misjudged blast. Today the location is cared for by the National Trust and recently Wheal Owles has had a new role as Wheal Leisure in the BBC production of *Poldark*.

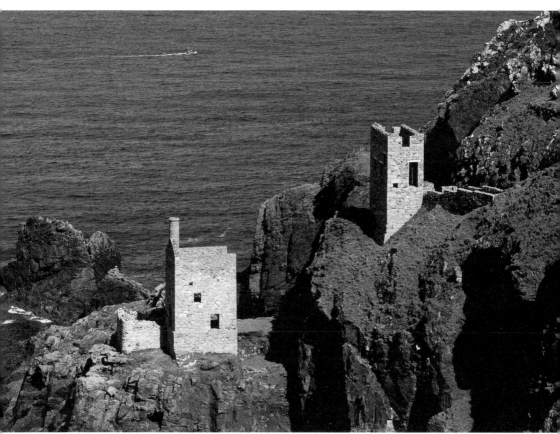

The iconic ruins of Crowns engine houses.

28. Men-an-Tol

Meaning 'holed stone', this unique Bronze Age megalith lies off the Morvah to Madron road in an area that is rich in prehistoric remains. Look out for the limited roadside parking just past Bosullow and a short walk along a farm track brings you to a little patch of field in which are set three stones, the central one circular with a hole in the middle. There is actually a fourth stone nearby but this has fallen over. Their original purpose is lost in the mists of time, but in recent history these stones are associated with cures for a number of conditions. One such legend claims that a child can be cured of rickets by passing the infant through the hole nine times.

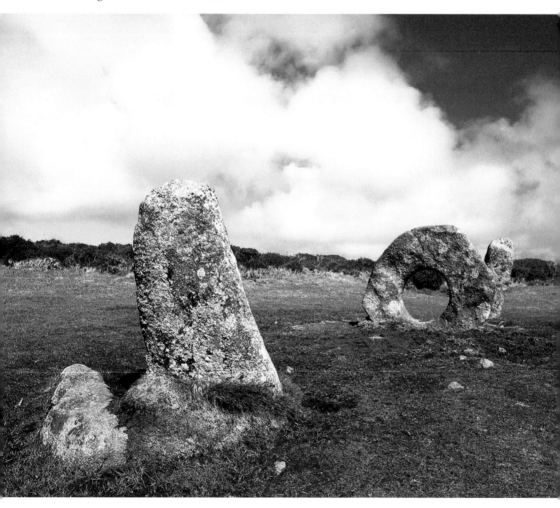

Men-an-Tol.

29. Zennor

Look up any gazetteer of English villages and the chances are that Zennor will be the last entry, appropriately enough for this is one of the most western settlements in the country. The Church of St Senera with its squat tower is twelfth century and has a list of rectors going back to 1271. The guide book relates that a haughty Londoner made a disparaging remark about the size of the village and was promptly told that Zennor was a church town when London was nothing but a cluster of huts.

Most visitors to the church come looking for the mermaid on a bench end in the side chapel, which was carved at least 500 years ago. The legend tells how she visited the church in order to seduce a member of the choir, tenor Matthew Trewhella. One Sunday he followed her to the coast at Pendour Cove where she enticed him into the sea never to be seen again. This is probably one of the folk tales that were propagated by Droll Tellers, travelling minstrels who used to visit these far-flung villages to entertain the locals. In the same tradition during the nineteenth century was Henry Quick, who was known as the Poet of Zennor. He travelled around reciting his verses and ringing a bell to announce his arrival.

Zennor and (inset) mermaid carving, St Senera.

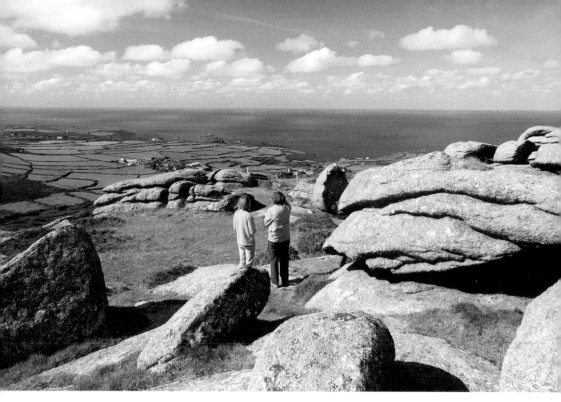

The view from Zennor Hill.

During the First World War the novelist D. H. Lawrence and his German wife Frieda lived in the village. His habit of writing late in the evening with the window open fuelled the suspicion that they were German spies signalling to enemy submarines, eventually forcing the couple to leave the village.

Across the B3306 a footpath leads up to the summit of Zennor Hill, a granite tor that provides a fabulous view of the village and coastline beyond. The field patterns so clearly visible from here were laid out during the Bronze Age. Even older is Zennor Quoit, a megalithic stone tomb.

30. The St Ives Branch Line

Ask anyone to list their favourite railway journeys in Britain and you can be sure many of the top answers will involve seaside destinations. The St Erth to St Ives branch is one such line, and has been called the finest short railway journey in these islands. Opened in 1877, this little branch line was the last 5 miles of broad-gauge track to be laid by the West Cornwall Railway. Most of the early traffic carried fish to the London market but increasingly during the early part of the twentieth century trains brought tourists seeking a seaside holiday. They still come today, so much so that the line is one of the most successful branch lines in the country. This is helped by its short length, frequent trains, a park and ride scheme, and, of course, wonderful coastal scenery. During 2011 passenger numbers rose to over a quarter of a million. This would not have happened

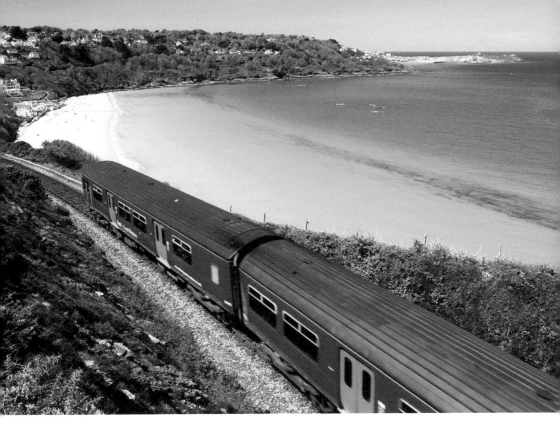

Approaching Carbis Bay on the St Ives branch line.

had Dr Beeching had his way, for the line was on his short list for closure, and had the distinction of a mention in the song 'Slow Train' by Flanders and Swann. Thankfully, Minister for Transport Barbara Castle issued a reprieve.

From St Erth, the line passes under the A30 trunk road and follows the west bank of the estuary of the River Hayle. On the opposite side is the town of Hayle, once an important port and engineering centre for the mining industry. The train stops at Lelant Saltings, an area of salt marsh that is a haven for wading birds and where the RSPB has a nature reserve. Park and ride passengers join the train here. The village of Lelant itself is the next stop. Lelant's Church of St Uny sits among the sand dunes, its patron the brother of St Ia, after whom St Ives is named. The church has a St Christopher window dedicated to the memory of Harry Sparks, who died in a shipwreck in the Indian Ocean in 1923 after drifting in a lifeboat for several weeks. Legend says that in the twelfth century there was a village here that became buried in sand, under what is now the golf course. When the railway was being built a number of skeletons were uncovered dating from prehistoric times. After Lelant, the line reaches the coast and there is a breathtaking view across Porth Kidney Sands at the mouth of the Hayle estuary to the expanse of Hayle Towans, famous for its 3 miles of golden sand, with Godrevy Island in the distance. Next the line skirts the golf course and reaches Carbis Bay, where the turquoise waters entice many passengers to stop off at the little halt to visit the beach. After Carbis Bay the train rounds one final headland before it approaches St Ives, passing Porthminster Beach with a tantalising view of the harbour across the bay, set amid turquoise waters and bathed in that special light that attracts so many artists to set up their easels here. In 2013, Her Majesty the Queen and the Duke of Edinburgh travelled on the line to make their first royal visit to the town.

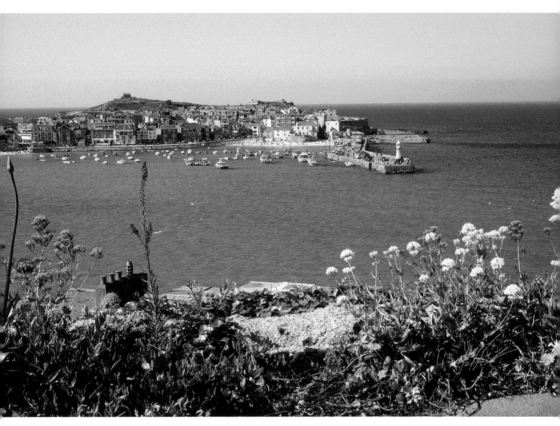

St Ives harbour.

31. Hayle Towans and Godrevy

Between the mouth of the River Hayle and Godrevy Island lie 3 miles of glorious yellow sandy beaches and dunes in the care of the Cornwall Wildlife Trust. Hayle or Upton Towans (Cornish for dunes) provide superb surfing beaches as well as a habitat for species such as the pyramidal orchid, glow worm and silver-studded blue butterfly. The octagonal lighthouse on the island of Godrevy was built in 1859 to warn ships off the Stones reef. It was the inspiration for Virginia Woolf in her autobiographical novel *To the Lighthouse*. Although set in the Hebrides, the book was strongly influenced by childhood holidays spent with her family in St Ives. In September 1892, when she was ten, they took a boat trip to Godrevy. All the party signed the Trinity House visitor's book, and she visited a second time two years later. Boat trips from St Ives to spot seals that bask on rocks around the island are still a popular excursion today. The lighthouse was automated in the 1930s, but in 2012 Trinity House replaced it with a modern LED light erected alongside it.

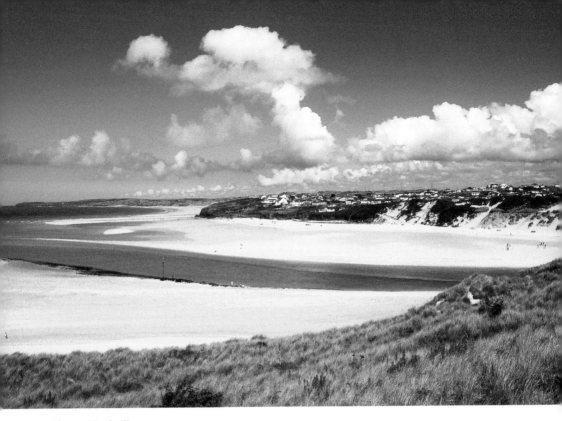

Above: Hayle Towans.

Below: Godrevy.

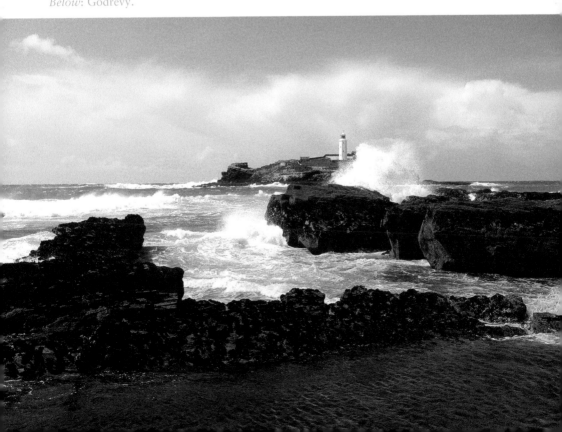

32. Trevithick Day, Camborne

Camborne's most famous son, Richard Trevithick, was born on 13 April 1771 at Pool, within sight of the rocky granite outcrop of Carn Brea. In 1772, the family moved to a cottage in the village of Penponds, which is today in the care of the National Trust and known as Trevithick Cottage. At the age of eighteen, Richard followed his engineer father into the tin mining industry and such was his aptitude that he became a consulting engineer two years later. In 1797 he married Jane Harvey, also from an engineering family, with whom he went on to have six children. Known as the 'Cornish giant', he was over 6 feet tall and powerfully built, so it was not surprising that he had a reputation as a wrestler.

Following James Watt's earlier patents, Trevithick was the first British engineer to experiment with high pressure steam. By the turn of the century, when Watt's patents expired, he was well on his way to developing the world's first steam-powered road locomotive capable of carrying passengers. This had its test run on Christmas Eve 1801, when it made its famous ascent of Tehidy Road in Camborne. This event is forever immortalised in the Cornish folk song 'Going up Camborne Hill Coming Down', beloved of male voice choirs and rugby teams alike. The engine earned the nickname 'Puffing Devil' and an exact replica, completed in 2001, is the star turn in

Camborne Trevithick's statue (left) and (right) the replica *Puffing Devil*.

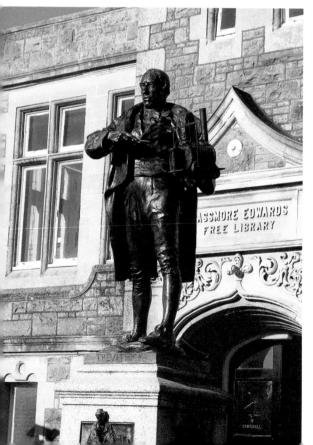
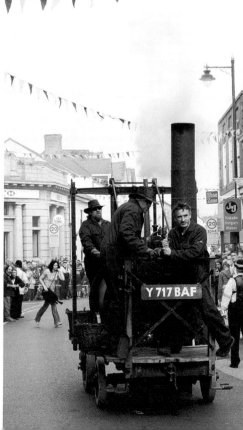

the steam vehicle parade on Trevithick Day, including the ascent of 'Camborne Hill'. Watching the driver and his helpers try to steer this unwieldy contraption through the town's narrow streets lined with onlookers gives us a clue to the origin of this soubriquet! Trevithick followed his road locomotives with a rail locomotive in 1804. This hauled a load of 10 tons of iron and seventy men for 9 miles at Penydarren Ironworks near Merthyr Tydfil in South Wales, an event that heralded the beginning of the railway age. In 1808 he built what was to be his last steam railway locomotive, which he named *Catch Me Who Can*. He took the engine from Bridgnorth, where it was built, to London, where he had set up a circular track near Euston Square. Here the engine and carriages were demonstrated against horse power in a steam circus, but again he had to halt the venture, this time due to a derailment.

After enduring bankruptcy and a bout of typhus, in 1816 Trevithick set sail for Peru, and spent the next eleven years travelling around South and Central America. His adventures included a stint in Simon Bolivar's revolutionary army, and he had a narrow escape from the jaws of an alligator. Penniless, he returned to Falmouth in 1827 with only the clothes on his back. He had been fortunate enough to have met steam pioneer Robert Stephenson in Costa Rica, who gave him enough money for his fare home.

Trevithick died in a hotel room in Kent on 22 April 1833. He was penniless and alone. He was buried in an unmarked pauper's grave in Dartford. In the years that followed his death, his contribution to steam engineering has been commemorated in Westminster Abbey, where a stained-glass window was erected in 1888. This depicts nine Cornish saints with Trevithick himself as St Piran, Cornwall's patron saint. In 2007 a blue plaque was unveiled on the wall of the Royal Victoria and Bull Hotel in Dartford, where he died.

In the town of his birth, a magnificent statue outside the Passmore Edwards Library was unveiled by HRH Prince George in 1932 in front of 10,000 people. Sculpted by L. S. Merrifield, it depicts the Cornish giant holding a model of his locomotive and a pair of dividers. As a living memorial, in 1984 the Trevithick Society planned the first Trevithick Day, which was held on 28 April. Special dances were devised, with the morning dance consisting of girls dressed as bal maidens, women who worked on the surface dressing the tin ore, and in the afternoon the Trevithick Dance, with the women wearing the Cornish colours of gold edged with black. The highlight is a parade of rarely seen steam vehicles, latterly including the appearance of the replica 'Puffing Devil'. Trevithick Day is held on the last Saturday in April.

33. Carn Brea

At a height of 738 feet, Carn Brea dominates the view from the A30 trunk road as it skirts Redruth. At the summit is a granite monument erected in 1836 in memory of Sir Francis Basset, enobled as Lord de Dunstanville of Tehidy. He might be familiar from Winston Graham's *Poldark* novels, which give a more or less accurate picture of a mine owner who used his political and economic influence to improve the welfare of miners in Cornwall.

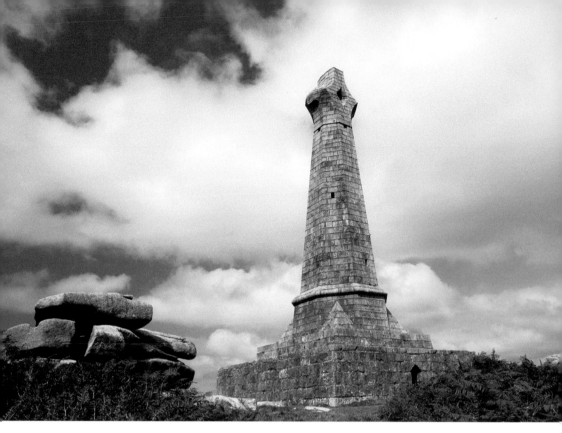

Monument to Sir Francis Basset, Carn Brea.

Carn Brea can be reached from the mining village of Carnkie, where modern bungalows and miner's cottages sit cheek by jowl with ruined chimneys and engine houses. Look out for a narrow road signposted to Carn Brea Castle. There is also a car park at Wheal Basset Stamps engine house where walkers can access a number of footpaths. At the top we find typically moorland scenery with granite tors. Views are of course spectacular, especially of the north coast as far as our next gem, St Agnes Beacon. To the south the landscape is dotted with ruined mine chimneys, engine houses and processing works. This area yielded the most accessible deposits of tin in Cornwall, known as the Great Flat Lode, so-called because the lode had an unusually shallow slope and was easier to work, not requiring as much vertical digging as many Cornish mines. Mining ceased here just after the First World War, and since then Cornish miners have exported their skills all over the world.

As part of a week of celebration of Cornwall's mining heritage, on a late June evening in 2008 the view from Carn Brea took a step back in time as straw fires were lit under the chimney stacks of twenty-one long abandoned engine houses. Smoke once more billowed from these chimneys and for a few minutes, the landscape changed as the brisk wind blew the smoke over the small mining communities of Troon and Carnkie. Around 5,000 people made their way up to the top of Carn Brea to get a view of this once-in-a-lifetime spectacle, together with musicians and choirs to add to the atmosphere.

North Cornwall

34. St Agnes Beacon and Wheal Coates

We continue the mining theme as we travel northwards along the coast to St Agnes, another mining village where chimney stacks sit almost in the back gardens of modern bungalows and terraced cottages. Take the coast road towards Chapel Porth to find Wheal Coates, a tin mine that was operating between 1802 and 1913. It can either be approached from Chapel Porth along the cliff path or from the National

The Towanroath engine house at St Agnes.

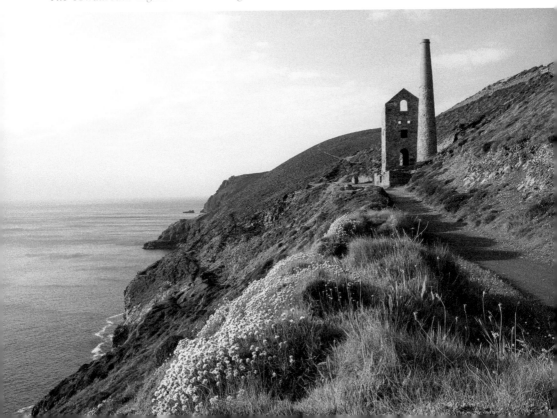

Trust car park at Wheal Coates. There are several engine houses here, part of a plant that crushed and processed the ore. The mine itself descended via the Towanroath shaft, over which the picturesque and much-photographed lower level pumping engine house, built in 1872, sits facing the Atlantic. The heathy cliffs around these ruins are littered with mining waste, on which purple heather flourishes. The coast path continues northwards to St Agnes Head, where I once encountered a bagpiper practising with only the gulls to hear.

After Wheal Coates the road brings us to the footpath up to St Agnes Beacon. This conical hill is an example of a rare Cornish heathland habitat. From the 600-feet-high summit there are extensive views of the coast from St Ives to Perranporth, our next gem.

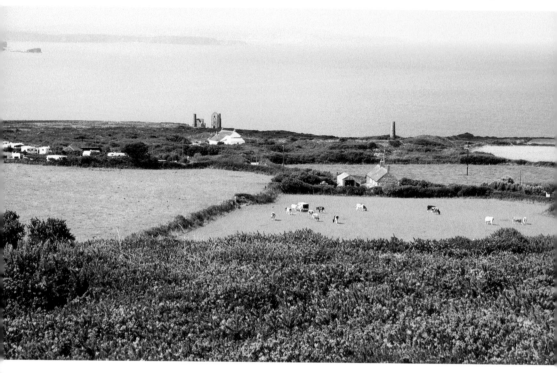

Above and left: Views from St Agnes Beacon.

35. Penhale Sands, Perranporth

Hidden behind the seaside village of Perranporth lie 4 square miles of grass-covered sand dunes, bursting with rare plants and some twenty-seven species of butterflies. The dunes can be accessed from the beach via a caravan park, or from a footpath off the road to Cubert. Either way, take your bearings carefully, as it is easy to get lost among these grassy mounds. If you are lucky, you may stumble upon an ancient Celtic cross, weathered and lichen-covered, the spot to which every year a thousand Cornish folk make a pilgrimage to honour the man who gave the Cornish nation its religion, flag and future industrial wealth. This is the cross of St Piran, the patron saint of Cornwall and of its most famous industry, tin mining. Like many religious men living in Ireland in the sixth century, he crossed the Irish Sea to take Christianity to other Celtic nations, miraculously floating on a millstone and coming ashore on the north Cornish coast at what is now named Perranporth (Piran's beach) in his honour. In the sand dunes he built a cell, from where he preached and travelled all over Cornwall.

The connection with tin arises from an incident one winter's night when St Piran had stoked up a hearty fire to warm himself. A black stone, forming part of the hearth, suddenly cracked in the heat and molten white metal began to flow out. The stone was cassiterite, and St Piran had discovered how to smelt tin. This has earned him a place in the heart of tin miners, and, legend says, was the birth of the Cornish flag, a white cross on a black background, representing the white tin flowing from the black ore. In fact, the Romans had previously found and smelted tin in Cornwall, but after their departure the know-how had been lost.

Following his death at a legendary 200 years old, an oratory was built in the dunes, which later in the tenth century became buried in shifting sands and had to be abandoned. A new church was then built some distance away, next to the ancient Celtic cross. Eventually, this building too became engulfed by sand, and around 1800 much of the fabric, including the tower, was used to build a church at nearby Perranzabuloe, which means 'St Piran in the Sands'. In 1835, the oratory was uncovered and later in 1910 it was encased in a concrete shell for protection. One of the oldest Christian sites in England, in 2014 it was uncovered again, although its protective walls of concrete blocks make it resemble a building site. A tall, modern cross stands nearby, a much-needed landmark for modern pilgrims in this vast expanse of dunes!

There have been a number of archeological digs here. The saint's Irish origin was confirmed when it was discovered that the construction of the oratory is similar to Celtic Irish churches. Bones found under the altar may be those of Piran himself. The oratory building was surrounded by a large burial ground, and a skeleton of a woman with a child in her arms was found near the door. A few hundred yards away is the site of the ancient Celtic cross, like that of St Andrew with diagonal beams, which was recorded as a boundary by King Edgar of Wessex in a charter of AD 960. Curiously, one of its four holes remains closed, as though the sculptor did not have time to finish it.

St Piran's Day is celebrated on 5 March, and the annual pilgrimage to the saint's oratory takes place on the Sunday following. A play depicting events from the saint's

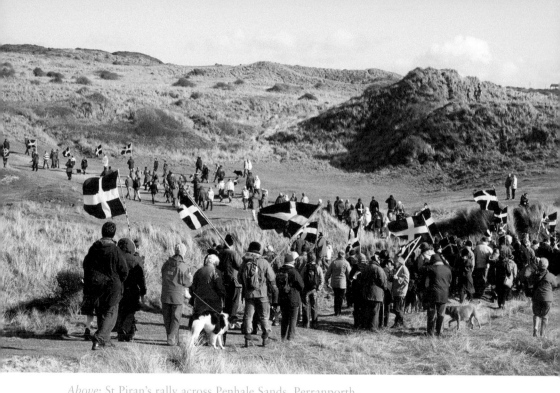

Above: St Piran's rally across Penhale Sands, Perranporth.

Below: The ancient cross of St Piran, Penhale Sands.

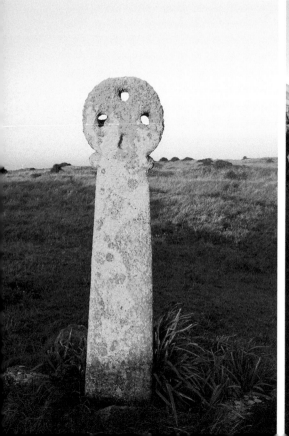

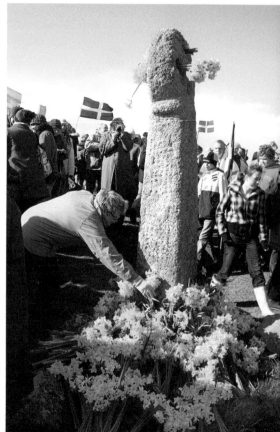

life is performed at the oratory site, then the procession moves to the ancient cross, walkers carrying black and white flags and bunches of daffodils. The actor playing the saint makes a rallying speech before the singing of Cornish anthems, including the famous 'Trelawney'. Before the crowd disperses bunches of daffodils are laid at the foot of the cross, a gift of Cornish gold for the saint who gave them tin.

36. Polly Joke and West Pentire

Polly is not a local barmaid, but a small sandy cove sandwiched between the headlands of West Pentire to the north and Kelsey Head to the south. Neither is she funny, her name meaning Jackdaw Cove in Cornish. Quieter than the larger beaches at Crantock and Holywell, it can be reached by a fifteen-minute walk from car parks at West Pentire.

If you come here in late June you will be in time to admire the wildflower meadows created by the local farmer in conjunction with the National Trust. Every year a different area of the barley fields is ploughed in the autumn and left free of crops to allow a magnificent display of red poppies and yellow corn marigolds interspersed

A wildflower meadow near Polly Joke.

with white sea campion, for the soil conditions in this part of Cornwall are among the best in the country for growing these arable wildflowers. One year I visited at the same time as an art group and saw ladies painting wearing floppy hats sitting amid the poppies, backlit in the sun. The scene could have come straight from a French impressionist's brush and I imagined Monet himself setting up his easel to commit this scene to canvas. There are always plenty of photographers, and for a couple of weeks each year these few small fields must be among the most photographed acres in the country.

37. Porth Island

Porth is a village that has almost been absorbed by the sprawl of Newquay. Also known as Trevelgue Head, Porth Island is an ancient monument since it contains Bronze Age barrows, fortifications and the remains of an Iron Age village. Reached from Whipsiderry on the north side of Porth Beach, the island is separated from the mainland by a narrow bridge. Come in May and the headland is a mass of sea pinks. If you have some cobwebs to blow away, come during a winter storm. Crossing the bridge as the sea surges in is an exciting experience, then crest the slope to get a view of the boiling sea around the rocky islands to the north. Best of all, this headland has a famous blowhole, Mermaid Cave, which is best experienced at half tide and in the teeth of an Atlantic gale!

Porth Island.

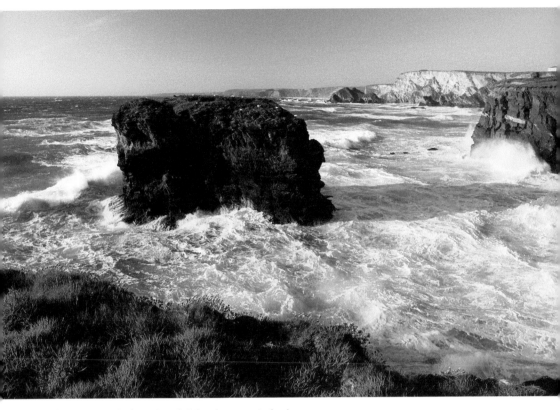

The view north from Porth Island on a windy day.

38. Bedruthan Steps

The coastline between Newquay and Padstow is something special, even for Cornwall. At Bedruthan nature has sculpted some of her best work along the beach as the softer rock has been eroded away leaving stacks of harder rock jutting into the sea. Come here in late May when the cushions of sea pinks and yellow trefoil flowers form a carpet all along the cliff edge. The beach was first discovered by Victorian tourists, attracted by the legend of a giant named Bedruthan who used the stacks as stepping stones. A staircase was built at around this time to access the beach from the clifftop, and this is thought to be the origin of the name. They also named one of the stacks Queen Bess rock, having discerned a resemblance to the Tudor monarch. The original stairs have long since been washed away, as has Queen Bess's head, but the National Trust have built a vertiginous new staircase of 120 steps, which can be reached from the car park at Carnewas. Also here is a shop and tearooms housed in some old mine buildings, and the cream teas are recommended – the scones are to die for!

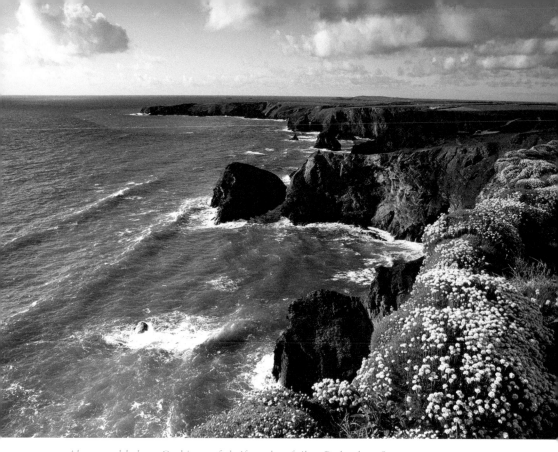

Above and below: Cushions of thrift and trefoil at Bedruthan Steps.

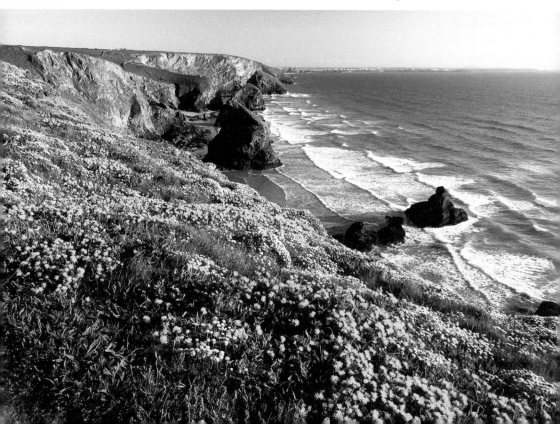

40. St Enodoc

If the biblical advice against building a house on sand had been heeded by the builders of this curious little church, they may have ventured further inland. In fact, the building's foundations are on rock, but the surrounding dunes have moved since the thirteenth century when the little stumpy spire was added, and only two centuries later the church had been abandoned and was buried in the windblown sand. This led to the local belief that it was sinking and it was given the nickname 'Sinking Neddy'. A new vicar, Revd Hart-Smith, instigated a restoration, which was completed in 1864.

To reach the church, visitors need to journey a mile or so across the dunes from either Rock, which lies across the Camel estuary from Padstow to the south, or Trebetherick to the north. They also risk the hazards of the golf course, and once on the path, which

St Enodoc Church and Sir John Betjeman's slate headstone.

is waymarked by white-painted boulders, the distant spire, which beckons like a bent stumpy finger, disappears and reappears deceitfully from among the dunes. This is an experience that everyone's favourite poet Sir John Betjeman observed in his poem 'Sunday Afternoon Service in St Enodoc Church, Cornwall'. The single church bell, the 'tinny tenor' of the poem, was taken from the wreck of the *Immacolata* in 1875. Betjeman holidayed at Trebetherick since childhood and had a deep love of this part of Cornwall and its churches. After his death in May 1984, he was buried in the churchyard where his mother also lies. His grave is marked by a finely carved headstone of Cornish slate. No Westminster Abbey burial for one of England's best-known laureates, he lies within earshot of the tinny tenor and the sea, one of Cornwall's favourite adopted sons.

41. Tintagel

Tintagel's ruined castle is world famous, partly because of its spectacular location and partly because of its association with the legend of King Arthur. There have been fortifications on the site since the Roman occupation, and there was much activity here in the fifth century with evidence of trade with the Mediterranean. The present-day ruins date from medieval times when Richard, Earl of Cornwall bought the island on which the castle is partly built, dating back to the thirteenth century. There was further expansion but by the end of the sixteenth century it was no longer in use.

The island site of Tintagel Castle seen from Glebe cliff.

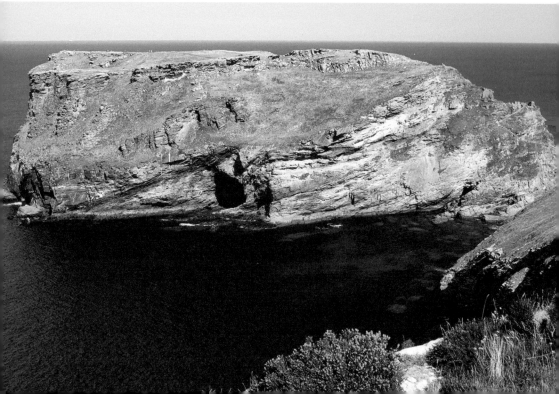

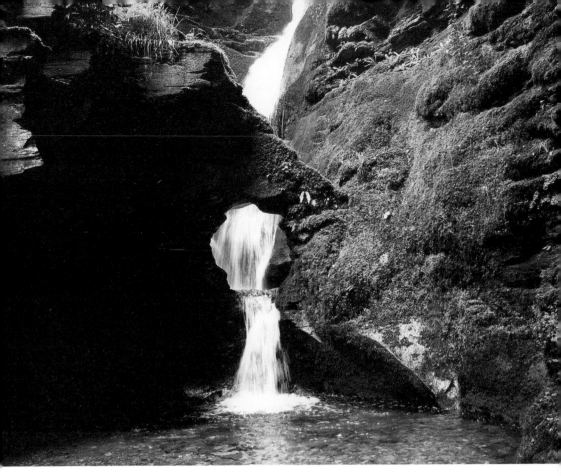

St Nectan's Kieve.

43. St Juliot's Church, Hennett, Boscastle

In the late nineteenth century, the Church of St Juliot had fallen into disrepair and the parish had collected enough funds to rebuild it. A young architect travelled from Dorchester to carry out a survey. His name was Thomas Hardy, an aspiring novelist, and he stayed with the vicar and his sister-in-law Emma at the rectory. Hardy fell in love with Emma, whom he later married, and they spent many hours walking in the Valency Valley and out to the cliffs at Beeny. Hardy used the experience in his early novel *A Pair of Blue Eyes* in which a young architect arrives in North Cornwall to survey a church and falls in love with the rector's daughter. After Emma's death in 1912, he returned the following year and arranged for the erection of the memorial plaque that we see on the north aisle. This visit also bore literary fruit as it inspired his *Poems of 1912–13* in which he expressed his feelings for Emma from whom he had become estranged during the later years of their marriage. After his own death

Above: Hardy memorials at St Juliot's Church, Hennett.

Below: The view from St Juliot's across the Valency Valley.

in 1928, a plaque to his memory, also of his own design, was erected alongside his first wife's. His time at St Juliot, which has lovely views of the Valency Valley, is today remembered in an etched-glass window by Simon Whistler, son of the glass engraver Laurence Whistler, whose beautiful windows adorn the Church of St Nicholas at Moreton in Dorset. It celebrates Hardy's time in Cornwall with designs based on three of his poems, illustrating his journey from Dorset, a picnic beside the river, and his poem set on Beeny Cliff.

In August 2004, an afternoon of heavy rain turned the Valency into a torrent, which swept down the valley to Boscastle harbour, taking vehicles, buildings and bridges with it. Few who saw the news footage will forget the sight of camper vans and cars being carried by the flood through the harbour to end up on the sea bed. A total of seventy-five cars, five caravans and six buildings were washed away. Today the village, which is in the care of the National Trust, has been restored, and inhabitants remain thankful that no lives were lost that afternoon.

44. Morwenstow

Leaving Tintagel and heading towards Bude, the coastline takes a sharp turn to the north bound for Hartland Point and Devon. The coast here consists of vertiginous cliffs with dangerous striated rocky ledges that before the days of modern navigation became a graveyard for shipping that had strayed off course for the Bristol Channel.

Hawker's rectory, Morwenstow.

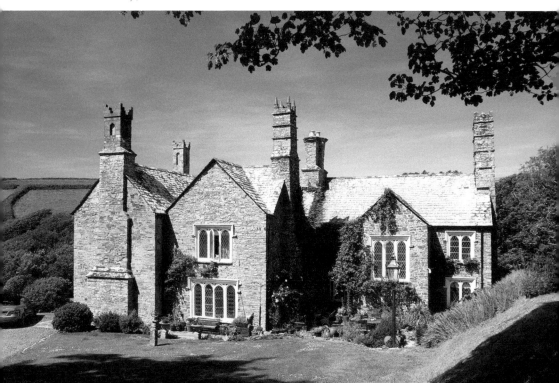

One man who did his best to ensure that the sailors who perished here got a Christian burial was Robert Stephen Hawker, the vicar of Morwenstow between 1834 and 1875. Hawker was a truly eccentric parson, walking his pet pig around his parish and sometimes dressing as a mermaid. The vicarage, which he had built next to the church with its fine tower, has chimneys modelled on three other West Country churches with which he had connections: Tamerton, Whitstone, and Stratton, plus Magdalen college, Oxford. The fifth represents his mother's tomb. Above the door he placed this inscription:

> A House, a Glebe, a Pound a Day;
> A Pleasant Place to Watch and Pray.
> Be true to Church – Be Kind to Poor,
> O Minister for evermore.

In the churchyard where some forty drowned sailors are buried is a figurehead, actually a replica, from the brig *Caledonia of Arbroath*, wrecked near here in 1842. The original is inside the church. The driftwood he collected was used to built a tiny hut looking out to sea towards the island of Lundy. Here he would smoke opium and write poetry, including the famous 'Song of the Western Men', which was later adopted as the Cornish national anthem 'Trelawney'. Sitting beside the cliff path, today the hut is the smallest building in the care of the National Trust. The Rectory tearooms at Morwenstow are recommended.

St Morwenna, Morwenstow.

Bodmin Moor

45. Roughtor and Brown Willy

On the northern edge of Bodmin Moor, these twin granite peaks are Cornwall's highest hills at just over 1,300 feet. This is one of the most accessible parts of the moor to walkers, with a convenient car park signposted off the A39 near Davidstow. From the car park a clapper bridge crosses a stream, just beyond which is a fenced area enclosing an inscribed granite post. This marks the spot where in April 1844 the murdered body of an eighteen-year-old servant girl, Charlotte Dymond, was found. The investigation was quick, and much of the evidence inconclusive by today's standards, but resulted in the conviction of her fellow servant Matthew Weeks, who was later hanged at Bodmin Jail watched by a crowd of 20,000 people.

Showery Tor and Roughtor.

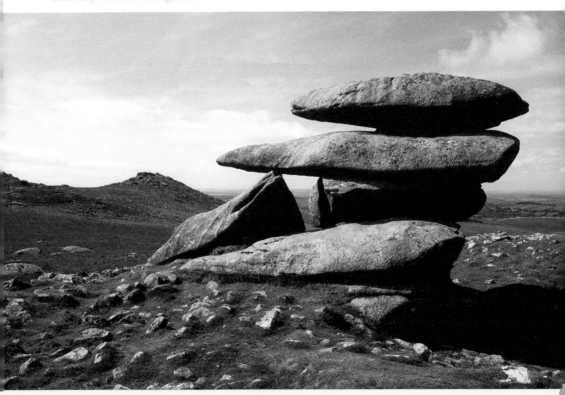

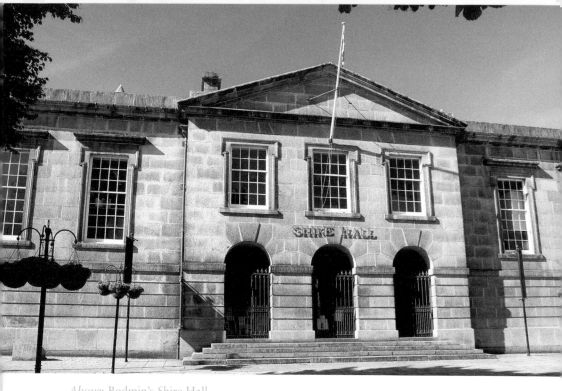

Above: Bodmin's Shire Hall.

Below: Ruins of St Thomas Beckett Church, St Petroc's tower (left) and (right) Bodmin Jail.

A longer walk from Minions heads along the old railway track bed towards the natural rock formation of the Cheesewring. A pile of weathered rocks situated high above a disused quarry, these resemble slabs of apple pulp left after the juice has been pressed or 'wrung off' during cider making, confusingly called a cheese. According to yet another legend, they are a result of a rock throwing contest with a giant, but in fact they are a result of natural erosion, a more extreme version of the piles of granite we see all over these moorland tors. In the eighteenth century a strange character called Daniel Gumb lived in a cavern among the rocks where he studied geometry and carved figures on the wall, some of which can still be seen if you know where to look. As a result of its volcanic origin, this corner of the moor is heavily mineralised, and is littered with the remains of spoil heaps and mine buildings from the nineteenth century. While there is evidence of Bronze Age mining in the area, commercial exploitation began in 1836 when South Caradon Mine hit a rich seam of copper. Soon the nearby Phoenix United and Prince of Wales mines were also in production. The ruins of the Prince of Wales engine house, clearly visible from the Cheesewring, hint at what an impressive building it was until its closure in 1914. Imagine what this peaceful area must have been like during its heyday, with chimneys belching smoke and steam, railway trucks on the move, and the noise of hundreds of men and women at work. The area is now part of the Cornwall and West Devon Mining Landscape World Heritage Site, and near Minions the Phoenix engine house has been converted into an Information centre.

The Cheesewring (left) and (right) Prince of Wales engine house.

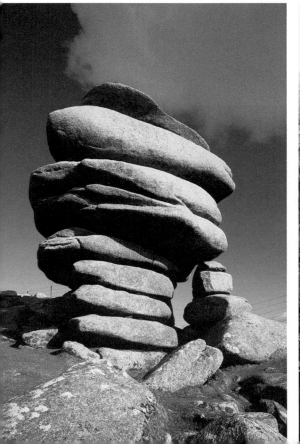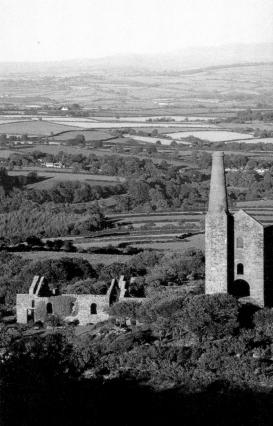

Five ancient crosses can be found in the churchyard, including one known as St Neot's stone. This is the finely decorated shaft of a ninth-century Celtic cross said to have been gifted by King Alfred. It is the only remnant of a previous building, part of a college of priests known to have existed at the time of the Norman Conquest.

48. Minions, the Hurlers and the Cheesewring

In the shadow of the television mast atop Caradon Hill on the south-eastern edge of Bodmin Moor lies the village of Minions, the highest settlement in Cornwall. Apart from sharing a name with some famous yellow cartoon characters, Minions has lots of fascinating things to see. Just outside the village are three ancient stone circles called the Hurlers. These date from the Bronze Age (around 1,500 BC) and their purpose is unknown. As usual there is a legend to explain their origin, and this one tells us that they are men turned to stone for playing the game of hurling on the Sabbath. Two stones adjacent to the circles are known as the Pipers, who suffered the same fate for playing their pipes on a Sunday.

The Hurlers.

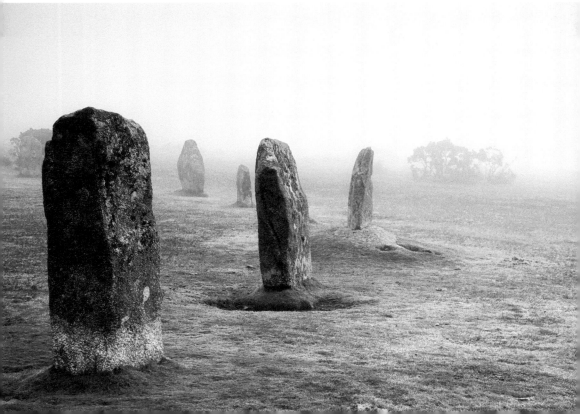

The St Neot window.

The stained-glass windows were restored in the early nineteenth century by John Hedgeland after 300 years of neglect. One can only imagine the cost involved, but the effort was worth it. There are seventeen windows in total, twelve dating back to the sixteenth century, and about half the glass is original. The best examples are sited on the south and east side of the church to make the most of the light. Subjects include biblical stories starting with the creation and the story of Noah. The Noah window in particular is worth the visit alone, the anonymous artist who created it demonstrating his mastery of the artform. The rest of the windows were donated by worthies or funded by public subscription, and feature depictions of saints together with representations of the donor families. A window is devoted to New Testament evangelists. There is also a window depicting the story of St George showing incidents that are not recorded elsewhere. Several windows were donated by villagers, the most famous of which was donated by the men of the village, and tells the story of St Neot himself. This is on the north aisle and does not catch the best light, but the story of the fishes is wonderfully illustrated. It is believed that the windows were first commissioned by Robert Tubbe, vicar here between 1508 and 1544. Hedgeland added four more windows during his restoration work, and the final west window in etched glass was commissioned as recently as 2004.

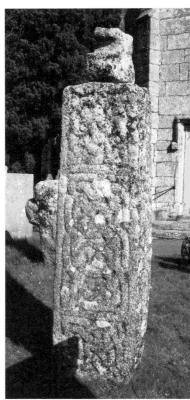

St Neot's Holy Well (left) and (right) St Neot's Cross.

cloth hang from the branches nearby as votive offerings. Like wells in the Peak District, it is dressed as part of the flower festival held in the church.

One legend says that the saint had a daily ritual of standing up to his neck in the well water reciting all 150 Psalms. Known as the Pygmy Saint, he was reputed to be only 4 feet tall. One day he found three fish swimming in the well, from which sprang the typically Celtic story that is told in one of the stained-glass windows in the church. It carries a modern conservation message. An angel informed him that he could eat only one fish a day, in which case the supply of fish would be maintained. One day the saint was ill and his servant caught two of the fish and cooked them, boiling one and grilling the other. Horrified, he instructed the servant to return the cooked fish to the well, where they miraculously returned to life. This led to St Neot becoming the patron saint of fish.

After his death in 877, the saint's body remained in Cornwall. One historian records that in 974, it was stolen and taken to Huntingdonshire. Apparently, this episode of bodysnatching is the reason for the Huntingdon town bearing the same name as the Cornish village. However, this story is regarded as a fabrication by some, including the writer of a verse found in the church: 'Some say his bones were carried hence … but hereto we say, No!'

Bodmin also has a number of military connections. To the south of the town, on Beacon Hill, is an obelisk in memory of General Sir Walter Raleigh Gilbert, who was born in the town in 1785 and took part in military actions in India and Afganistan. Among the prizes brought back from these conflicts was the famous Kohinoor diamond, which, as part of the Crown Jewels, was housed for safe keeping in Bodmin Jail during the First World War, along with the Domesday Book. The museum of the Duke of Cornwall's Light Infantry continues the military connection, housed in an impressive building opposite the steam railway.

In the car park near the Shire Hall a tomb and drinking trough for dogs can be found. The benefactor was Prince Chula Chakrabongse of Thailand, who lived near Bodmin and was related to King Mongkut, on whose life the musical *The King and I* was based. The tomb is dedicated to two of his dogs, Joan, a wire-haired terrier, and a bulldog named Hercules.

47. St Neot

St Neot is a pretty village on the southern rim of the moor centred around a magnificent fifteenth-century church. Dedicated to St Anietus, it houses one of the finest collections of stained-glass windows in the country. The size of the church reflects the prosperity of the village at the time, which derived from the wool trade. Later, this was augmented by tin streaming and slate quarrying. While sheep still graze the moors, the tin mines and slate quarry are nowadays abandoned. The quarry's underground caverns were used to store the navy's supply of rum during the Second World War and as Carnglaze Caverns are now a tourist attraction.

Little is known of St Neot himself, and historians disagree over whether he and Anietus were the same person. One source says that he was the son of a Saxon king, related to Alfred the Great, and it is from a book about St Neot that we get the famous story of King Alfred burning the cakes. In this version of the story, he decided to forego worldly power to become a monk at Glastonbury, afterwards moving to Bodmin Moor. However, he still retained his political contacts acting as an advisor to Alfred, who is said to have visited him in Cornwall. A wooden tablet in the church tells us in rhyme that:

> His father was a Saxon king, St Dunstan was his teacher,
> In famous Oxford he was eke the first professed preacher.

A holy well dedicated to him is still to be found along a track beside the River Loveny, a few hundred yards from the church. The well has been covered with a cross as long ago as the eighteenth century and bears the inscription that it was restored in 1852, although the guidebooks say 1862. This was financed by the vicar, Revd Henry Grylls, who also wrote a guide to the windows. Even today strips of

of which a few small relics remain. On the north side of the town is the eighteenth-century jail, the first in the country to have individual cells and where in 1909 the last public hanging in Britain took place. Large crowds gathered to watch these executions, with railway excursions organised to take advantage of the line's proximity to the gallows. It was closed in 1927 after reaching the gruesome total of fifty-one hangings, and is now a tourist attraction, emphasising the ghastly and ghostly sides of its history.

Bodmin's church, dedicated to St Petroc, is the largest parish church in Cornwall. St Petroc, a Welsh missionary, founded an abbey here in the sixth century, giving the town its name from the Cornish 'bod' and 'monegh', meaning 'dwelling of monks'. Nothing survives of the abbey today. Later in the sixth century, St Petroc was driven out of Cornwall by Danish raiders, and his remains ended up in Brittany. Their whereabouts today are unknown, but the Oriental ivory casket in which they were kept is still in the possession of the church. St Petroc's Church was rebuilt in the fifteenth century in a massive community effort. The completed church boasted the tallest spire in the county, but maybe the builders were a little too ambitious, because it collapsed in 1699 after being struck by lightning. The churchyard contains the ruins of a fourteenth-century chapel dedicated to St Thomas Becket.

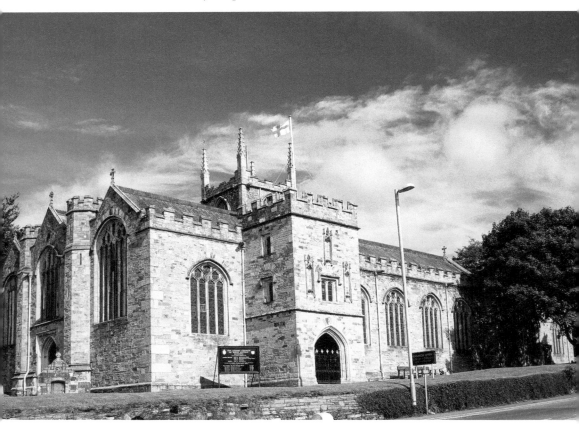

St Petroc's, Bodmin.

49. Altarnun

This moorland village is famous in fiction for its evil vicar who features in Daphne du Maurier's novel *Jamaica Inn*. It is only a mile or so to the east of the famous hostelry, the 'grim landmark' that was the inspiration for the book. Today the A30 trunk road speeds traffic past both the inn and the village, which is the centre of the largest parish in Cornwall and whose church is known as the Cathedral of the Moors. It contains much to interest lovers of stone and woodcarving.

Altarnun is centred around a twin-arched packhorse bridge over the Penpont river. This takes us to the fifteenth-century Church of St Nonna, the mother of St David. A sixth-century cross stands just inside the lychgate. Ahead the tower rises to a height of 100 feet and has been struck by lightning twice. Inside, the church's treasure is a fine collection of bench ends carved by Robert Daye between 1510 and 1530. There are seventy-nine of them, including a fiddler, a pastoral scene of sheep grazing on the moor, and one, possibly a self-portrait, autographed by Daye.

St Nonna, Altarnun.

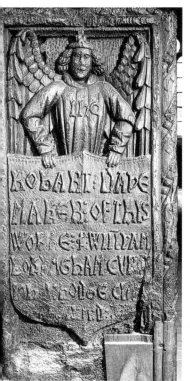
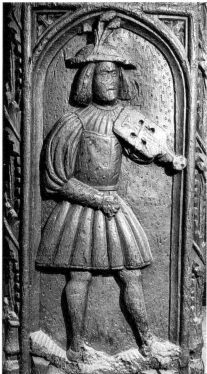

Sixteenth-century bench ends carved by Robert Daye, Altarnun.

The old Methodist chapel, now a private home, is also worth seeing. It has a bust of John Wesley, a frequent visitor to the nearby hamlet of Trewint, by sculptor Neville Northey Burnard, who was born in the next-door cottage. Some of his early work, carved with a nail on slabs of slate, can be found in the churchyard. His career took him away from this moorland village to London where his sitters included Edward VII, Gladstone and Thackeray, but his life ended in poverty in a Redruth workhouse after the death of his daughter led him to drink.

50. Launceston

Lying on the eastern edge of Bodmin Moor, no other Cornish town has quite the historic importance of Launceston. The county's only walled town, it is dominated by the ruins of its fine Norman castle. Sitting atop a grassy mound, its strategic importance as the gateway to Cornwall is clear from the views across the valley of

the Tamar into Devon. Originally known as Dunheved, the town's importance was such that there was a mint here during the reign of Ethelred II, one of only seventy in the country.

Like Trematon, the castle was built by a half-brother of William the Conqueror, Robert de Mortain. In the twelfth century, the outer bailey was added, the gateway arches of which still survive. Today the bailey is grassed and is maintained as a public park. The round tower of the keep, which dominates the town, was built in the thirteenth century on top of a steep mound when the castle was occupied by Richard, Earl of Cornwall, a brother of Henry III. Surprisingly it has never seen a shot fired in anger. By the start of the Civil War the castle had fallen into disrepair, and during the course of the conflict changed hands five times without resistance. As its military importance decreased in the eighteenth century, the castle became the county gaol and a place of execution. Prisoners held here included Sir Cuthbert Mayne, a Catholic martyr, and later George Fox, founder of the Quaker movement. For eight months he was held in squalid conditions in a tiny room in the north gatehouse. Launceston remained the county town until 1835, when it lost its status to Bodmin. Launceston's gaol had fallen into disrepair, and has passed into Cornish dialect, the term 'Lanson gaol' being used to describe a house full of clutter.

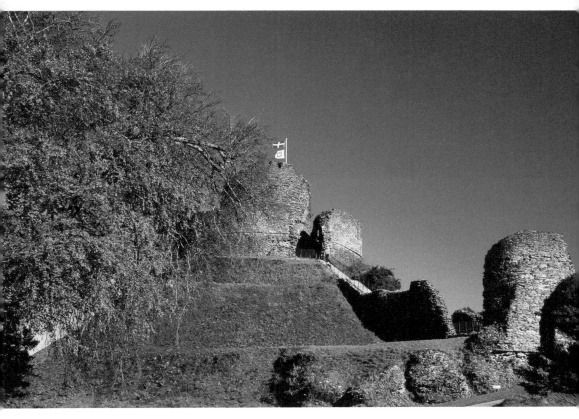

Launceston Castle.

Leaving the castle by the north gatehouse, we come upon a lovely row of red-brick Georgian town houses that were much admired by Sir John Betjeman. One of them, Lawrence House, built by a former mayor, is the town's museum. Another, now the Eagle House Hotel, was built for the constable of the castle in 1764, after, of all things, a lottery win! Up the hill towards the town square is another of Launceston's architectural treasures, the Church of St Mary Magdalene. This magnificent building is unique among Cornish churches in the richness of its carved granite exterior. The church we see today was built by Sir Henry Trecarrel between 1511 and 1524. Sir Henry had originally intended to build an elaborate manor house on his estate, but following the tragic death of his baby son he rebuilt the church using the masons he had planned to employ to decorate his home. The result is a spectacularly carved exterior, with every available square foot covered in coats of arms, Latin inscriptions, fern leaves, roses, carved figures of angels and men on horseback.

Of the medieval town walls only the south gate survives. Castellated, it has two arches, one over the busy street funnelling cars through one at a time, with a smaller one beside it for pedestrians. Above the arch is a small room with latticed windows, which once housed a small museum.

Lawrence House, Launceston.

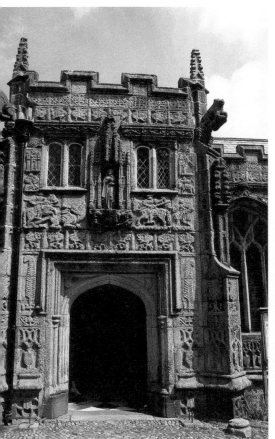 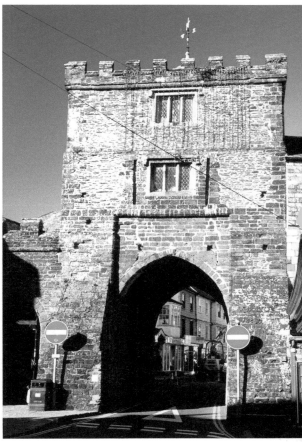

The carved exterior of St Mary's Church (left) and (right) Southgate.

We are almost in Devon, but Launceston is part of the Duchy of Cornwall, which has been in existence since 1337. The first Duke of Cornwall was Edward the Black Prince, who repaired the castle in 1353. More than 600 years later, in 1973, these ancient walls witnessed the investiture of the present duke, and Launceston castle continues to stand guard over the duchy.

Acknowledgements

I am grateful to Angeline Wilcox and Jenny Stephens from Amberley Publishing for providing the opportunity for me to write this book. All of the photographs are my own, and those taken at privately owned locations are reproduced with the kind permission of the proprietors. The information comes from many sources, too numerous to list, but I am particularly indebted to the unsung local historians whose church and parish guides are unfailingly helpful. In particular, I am grateful to Christine Edwards, whose researches have dispelled some of the long-standing myths about the Veryan roundhouses.

About the Author

John Husband grew up in the Cornish village of Gorran Haven and has lived all his life in the county. He has spent his career in the clay industry, has a PhD in Paper Science from the University of Manchester and is a Fellow of the Technical Association of the Paper Industry and a member of the Royal Society of Chemistry. A self-taught photographer and writer, he has written articles for *The Lady*, *The Countryman*, *This England*, *Evergreen* and *The People's Friend*.